MARK
ROTHKO
WORKS ON
PAPER

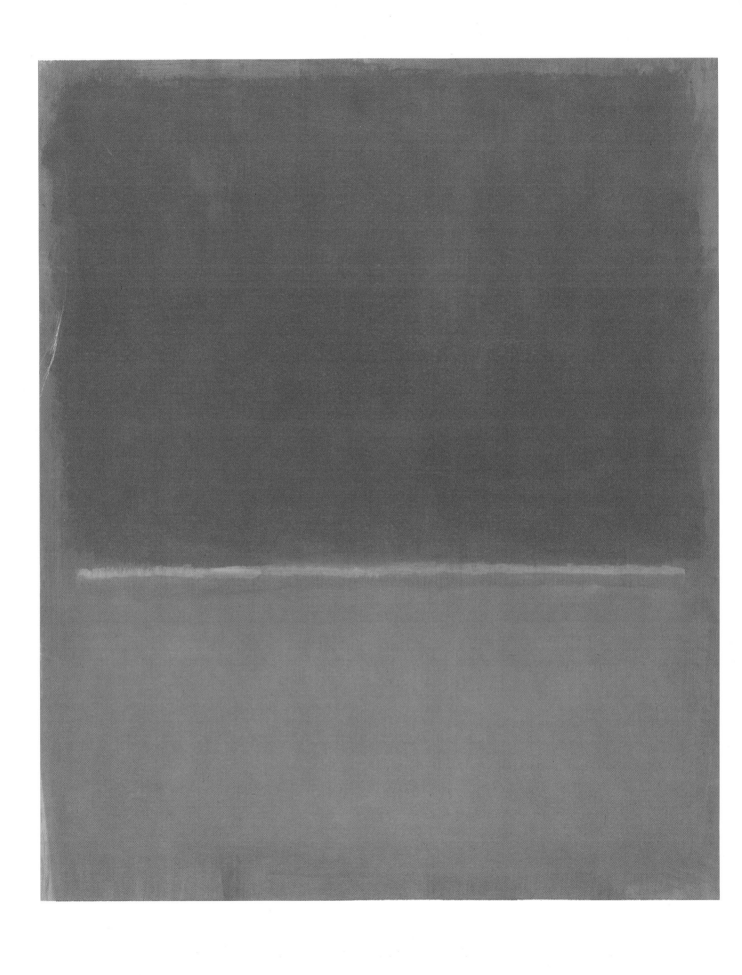

MARK ROTHKO

WORKS ON PAPER

BONNIE CLEARWATER

Introduction by Dore Ashton

HUDSON HILLS PRESS, NEW YORK

in Association with The Mark Rothko Foundation and The American Federation of Arts

Published in the United States by Hudson Hills Press, Inc., Suite 1308, 230 Fifth Avenue, New York, NY 10001−7704.
Distributed in the United States, its territories and possessions, Canada, Mexico, and Central and South America by Rizzoli International Publications, Inc.
Distributed in Japan by Yohan (Western Publications Distribution Agency).
Distributed in South Korea by Nippon Shuppan Hanbai.

Editor and Publisher: Paul Anbinder
Copy editor: Irene Gordon
Designer: Betty Binns Graphics/Betty Binns and Allen Moore
Composition: A&S Graphics, Inc.
Manufactured in Singapore by Tien Wah Press.

Library of Congress Cataloguing in Publication Data

Clearwater, Bonnie, 1957-
Mark Rothko, works on paper.
"This book has been published in conjunction with the exhibition Mark Rothko, Works on Paper, organized by the Mark Rothko Foundation and the American Federation of Arts with support from Warner Communications Inc. AFA Exhibition 84-4. Circulated May, 1984-September, 1986"—T.p. verso.
Bibliography: p.
Includes index.
1. Rothko, Mark, 1903-1970—Exhibitions. I. Rothko, Mark, 1903-1970. II. Mark Rothko Foundation. III. American Federation of Arts. IV. Title.
N6537.R63A4 1984 759.13 83-22843
ISBN 0-933920-54-7

This book has been published in conjunction with the exhibition *Mark Rothko: Works on Paper,* organized by the Mark Rothko Foundation and the American Federation of Arts with support from Warner Communications Inc.

AFA Exhibition 84-4
Circulated May, 1984-September, 1986

Frontispiece: Untitled, 1969 (Checklist number 79)

Cover illustrations: front, Untitled, 1968 (Checklist number 42); back, Untitled, 1969 (Checklist number 77)

CONTENTS

FOREWORD

The Mark Rothko Foundation has set as its highest priority the furthering of understanding and interest in creative arts through the example of Mark Rothko's work. The Foundation has received, as a principal beneficiary of Rothko's estate, some one thousand paintings, watercolors, drawings, and studies spanning over forty years of the artist's career. As part of a continuing commitment to share this unique collection with serious scholars and with audiences in this country and abroad, the Mark Rothko Foundation invited the American Federation of Arts to co-organize this exhibition in an attempt to give further insight into and a better understanding of the work and career of this important twentieth-century American artist.

This exhibition surveys Mark Rothko's works on paper from the late 1920s to his death in 1970, with primary focus on the richly colored paintings on paper done in the last few years of his life. These later works are virtually unknown to the public and not only relate to his larger well-known paintings of the 1950s, but stand alone as major works in and of themselves. The selection includes sixty-two major works and twenty-four sketches and studies for mural projects drawn almost exclusively from the Mark Rothko Foundation's holdings. Several important additional works were made available through the generosity of Kate and Christopher Rothko and Mr. and Mrs. David A. Wingate, New York.

There are many whom we wish to thank for making this project possible: first, the board of the Mark Rothko Foundation, Kate and Christopher Rothko, and Mr. and Mrs. David A. Wingate, for their willingness to share these works with museums on the tour; second, Bonnie Clearwater, Curator for the Mark Rothko Foundation, for selecting the exhibition and researching and writing the catalogue.

Thanks are due David Roger Anthony, Consultant, Dana Cranmer, Conservator, and Phillip Rivlin, Assistant to the Conservator, of the Mark Rothko Foundation; and James Barth, Antoinette King, and Susanne Schnitzer for their careful attention to the preparation and conservation of the works for the tour.

At the American Federation of Arts we wish to express our appreciation to Jeffery J. Pavelka, Exhibition Program Coordinator; for overseeing all aspects of the project. Other AFA staff to whom we are grateful for their contributions toward the project include Jane S. Tai, Associate Director and Exhibition Program Director; Carol O'Biso, Registrar; Susan MacGill, Assistant Registrar; Amy V. McEwen, Coordinator, Scheduling; Konrad G. Kuchel, Coordinator, Loans; Sandra Gilbert, Public Information Director; Lindsay South, Public Information Assistant; and Teri Roiger, Exhibition Assistant.

With respect to contributions to the catalogue and its production, we owe much to Dore Ashton for her informative and thoughtful Introduction; Betty Binns for the handsome design; Irene Gordon for editing of the manuscript; Christopher Burke and Carmen Quesada-Burke of Quesada/Burke, New York, for new photography; and Paul Anbinder, President, Hudson Hills Press, for his continued commitment to the publication.

Lastly, we are deeply grateful to Warner Communications Inc. for its financial support toward the organization of this project.

Donald Blinken, *President*
THE MARK ROTHKO FOUNDATION

Wilder Green, *Director*
THE AMERICAN FEDERATION OF ARTS

ACKNOWLEDGMENTS

I wish to express my gratitude to those individuals who generously offered their assistance, advice, and expertise: Wilder Green, Jane Tai, Jeffery J. Pavelka, Amy McEwen, and Konrad Kuchel of the American Federation of Arts, New York; William McNaught of the Archives of American Art, Smithsonian Institution, New York Division; Dore Ashton; Avis Berman; Leonard Bocour; Michael Boodro; Enid Brownstone; John Calhoun; George C. Carson, Carol B. Carson, and Jo Anne Carson; Irene Gordon; Sanford Hirsch of the Adolph and Esther Gottlieb Foundation, New York; Diane Waldman and Lisa Dennison of the Solomon R. Guggenheim Museum, New York; Jeffrey Hoffeld; Paul Anbinder of Hudson Hills Press, New York; John Krushenick; Katharine Kuh; Dominique de Menil; Mary Jane Victor of the Menil Foundation, Houston; E. A. Carmean, Jr., of the National Gallery of Art, Washington, D.C.; Gary Reynolds of the Newark Museum; Christopher Burke and Carmen Quesada-Burke of Quesada/Burke, New York; Arnold Glimcher of the Pace Gallery, New York; Irving and Lucy Sandler; Joseph Solman; Oliver Steindecker; Ronald Alley and Catherine Lacey of the Tate Gallery, London; Ealan Wingate; and Mark Francis and Clare Moore of the Whitechapel Art Gallery, London. Very special thanks to Barbara Neforos, Barbara Shikler, Cathy Shikler, and Laura Spitzer for their help in preparing this catalogue. I would also like to thank the staff of the Mark Rothko Foundation—David Roger Anthony, Dana Cranmer, Phillip Rivlin, and John Shaw—for their diligence in the preparation of this exhibition.

I am especially grateful to the board of the Mark Rothko Foundation—Donald Blinken, Dorothy C. Miller, Gifford Phillips, David A. Prager, Emily Rauh Pulitzer, Irving Sandler, and William Scharf—for their support and assistance. My deep appreciation to the lenders to the exhibition, Kate and Christopher Rothko and Mr. and Mrs. David Wingate. Finally I wish to thank my husband, James Clearwater, for his constant encouragement.

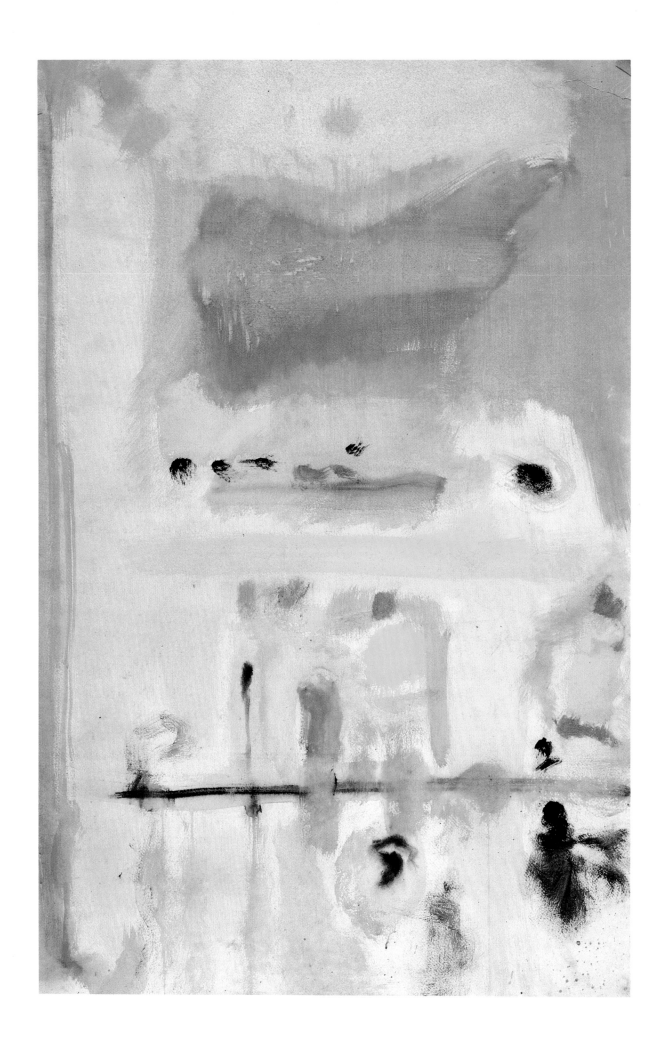

INTRODUCTION
by Dore Ashton

ROTHKO loved the Byzantine. I like to think he had encountered a wonderful inscription (an astounding inscription, really) in the Archiepiscopal Chapel at Ravenna:

> The light is either born here, or, imprisoned, reigns here in freedom.
> *Aut lux nata est aut capta hic libera regnat.*

Paradox and splendor—the two poles that border his life's work—are here summed up. Rothko more than any artist I have known succumbed to the lure of light, light that, as the Byzantine inscriptionist said, can be contained but never captured really; light that envelops us and is all things that we are not. In moving toward this ineffable beacon it was natural enough that Rothko should find his way in the light of paper, that most subtle of light-reflecting bearers, and that his works on paper should be as integral a part of his total vision as his easel paintings and murals. It was almost certainly his experience with the paradoxical nature of paper—absorbing and reflecting at the same time—that set him on his course to the great clearing away that his life's work represents.

I think that the clearing away of all incidental event was a temperamental imperative for him. He slowly came to terms with it and as his understanding of his own hunger dawned, he took the drastic measures that would release him from the conventions inimical to his temperament. There had been others in the history of his art who had known the same need. He admired, for instance, the later work of Fra Angelico, particularly the paintings in the cells at the monastery of San Marco. Fra Angelico had drastically simplified his motifs. Light was no longer a function of luxurious materials such as gold leaf and lapis lazuli, but a fogged, suffusing, hovering substance whose source is veiled. Each painting holds only two or three or four shapes, and they are almost always subordinate to the peculiar nature of the encompassing light. Fra Angelico had cleared away the flowers, the adoring angels, the brilliant skies, the musical instruments, in order to reveal a vision of a higher and far less defined experience, meant for meditation. Such a dramatic course occurs now and then in the history of art and I think the impulse to expel the ordinary, the mundane, the quotidian is lodged in certain temperaments and erupts regardless of circumstance. In the twentieth century it found several practitioners. Malevich certainly knew the need when he spoke of trying to reach the desert of pure feeling and when he resolutely set out to clear away everything that impeded his dream of

Untitled, 1949 (Checklist number 20)

illimited horizons. "Swim!" he exhorted his viewers in 1919, "the white free abyss, infinity, is before you." A note of ecstatic triumph sounds throughout Malevich's writings once he had freed himself from the things of this world, as when he declared, "I have destroyed the ring of the horizon and stepped out of the circle of things."

The circle of things was equally constricting for Rothko, who gradually discovered his own true needs. Like Malevich he wanted to express boundlessness within the bounds of his pictures, and to do that, all the clutter of the mundane world had to be banished. He spoke of the ideas and plans that existed in his mind at the start as "simply the doorway through which one left the world in which they occur." Clearing away and passing beyond were essential to what he called his enterprise. He meant to vacate the everyday world as Nietzsche had said the artist must in order to speak of the mythic, or eternal. Rothko spoke of eliminating all obstacles between the painter and his idea, and the idea and the spectator—a task that preoccupied him from his middle forties to the end of his life.

His attitude was instinctively shaped by an extreme susceptibility to music. Everyone who knew Rothko well noticed how deeply he craved music, and how willingly he gave himself to its transport. It was likely that Rothko's devotion to Nietzsche, and most especially to *The Birth of Tragedy* with its subtitle, *Out of the Spirit of Music,* was based on his recognition of Nietzsche's own reverence for the power of music. Nietzsche credited music with the possibility of giving to man a "direct knowledge of the nature of the world unknown to his reason." This was consistent with Rothko's needs at the time. The unwonted use of reason masked the elemental truths of the mythic world. Rothko, as he stated often in the late 1940s, wished to bypass the logic of the Western world. He longed for the abstracted condition, the condition of music, and in order to achieve it and to give his work, as he said, "the poignancy of music and poetry," he had to clear away so many things.

Much of the initial clearing away took place in the mid-1940s when Rothko worked a great deal on paper. His release from the world of objects occurred as he discovered the delights of watercolor. At times he seemed to be enchanted merely by the suggestive film that occurs as an artist wets down his paper, or by the bleeding lines that seep into the paper and emerge so magically with their indeterminate shadows on the surface. Or, when the tooth of the paper can be used to create a swift but interrupted line as a dry brush is dragged across it. Watercolor and gouache served his expressive purpose exceptionally well during the 1940s when he had visions of spaces expanding to infinity, the spaces of the beginning, when the world was clear. The traces of water itself—water, the medium from which all life emerged—seemed to excite his imagination and often during those years he played with floating effects. The mirror, also linked in so many mythic ways with water, was best suggested in the light of water-based media. If it were to be a question of transcending matter, then nothing was more adaptable than the grains of color so attenuated in the watercolor medium.

Probably the liberties increasingly evident in Rothko's works on paper from the mid-1940s to 1950 were inspired by his concourse with the works of European masters

frequently exhibited after the war. Rothko had been as stimulated by the Surrealists during the late 1930s as had his confreres in the ranks of the Abstract Expressionists. He had even experimented briefly with automatic drawing. Miró's paintings, especially, had attracted him. Of all the Europeans, it was Miró who most firmly insisted on the poetic character of modern painting and who sought, in his suggestive symbolizations, a myth-like atmosphere that could be, as Nietzsche thought, "a concentrated image of the world." To convey his image of the world, Miró had cast out many painterly conventions including mathematical perspective and painterly opacity. His thinly brushed canvases, and above all his extremely light-handed, cursive watercolors, brought together in a large exhibition at the Museum of Modern Art in 1941, held important cues for Rothko. Transparency in the service of transcending seemed a possible way.

What Rothko sought was a pictorial language in which he could restore the "aura" that the nineteenth century had somehow denied in painting. (Van Gogh was saddened by the loss. He wrote in one of his last letters, "I want to paint men and women with that something of the eternal which the halo used to symbolize, and which we seek to convey by the actual radiance and vibration of our color.") I think it likely that Rothko's experience with watercolor revealed to him the way to a radiance that could satisfy his longing to leave behind circumscribed spaces, to abandon what he referred to as the Renaissance box. "In my work," he remarked, "there is no box: I do not work with space. There is a form without a box, and possibly a more convincing kind of form." When he un-boxed his imagery toward the late 1940s, he naturally gravitated toward the fluent media, and even when he transformed his oil paintings, the lessons of the works on paper were apparent.

Once the source of the technique is acknowledged, it is not important how Rothko proceeded. I make no distinction between the works on paper and those on canvas after the late 1940s. The important thing is that he had found his natural language (for he believed that painting could be a language) and that his exhilaration was unbounded. On the many occasions I visited Rothko's studio I can never remember discussing techniques at any length. His imagery was consistently magical and as Baudelaire rightly maintained, you don't ask a magician for his formula. ("Painting is an evocation, a magical operation . . . and when the evoked character, when the reanimated idea has stood forth and looked us in the face, we have no right—at least it would be the acme of imbecility!—to discuss the magician's formulae of evocation.") Rothko had found his way beyond matter. Painting for him, and for quite a few of his friends, had to be mysterious, magical. Philip Guston, with whom Rothko used to talk late into the night during a certain period in his life, used to exclaim, "What is paint after all? Colored dirt." It was a question of transforming this colored dirt into an illusion of radiance; into a paradox in fact.

In all the essays into boundlessness that Rothko undertook, many of them on paper, the goal (perhaps only dimly perceived by the artist himself) was always the same: to get as close to his intuition of radiance as he could. Like Fra Angelico, Rothko disembarrassed himself of narrative detail with progressively more sober schemes. Once, during the last period of his life, I visited his studio and he unrolled a group of large paintings on heavy

paper in which color had given way to tone, and yet, in which the light was still animate. As I looked he reminded me, "The dark is always at the top." These paintings tended to be somber, and I was tempted to translate his remark into a comment on his own life, in which the satisfactions of public success had meant so little to his inner life. The truth was, however, that Rothko had always seen his paintings as analogues to his volatile emotional life. At the same time that he was working on the befogged last works on paper, with their faint allusions to oceans and dark skies, he was also making other paintings on paper in which scarlets and dense whites bespoke other emotions. He was a complex man.

Rothko had reduced his imagery to the most subtle analogies of states of the soul and, with a mixture of perplexity and exaltation, had pursued a vision. There are certain artists who await epiphany (in the way James Joyce had spoken of it) and covet it, and yet, never quite believe in its reality. They are modern artists. One feels Rothko had his moment sometime in the late 1940s and was never the same thereafter. He had great admiration for Giacometti who also coveted his moment of epiphany and who, like Rothko, spent the rest of his life trying to find the means, the precise means, of conveying his vision. Giacometti had written that

> the true revelation, the great shock that destroyed my whole conception of space and finally put me on the track I'm on today came in 1954 in a newsreel theatre. . . .
> After that, everything was different, the spatial depth and the things, and the colors and the silence. . . .
> On that day reality was revaluated for me, completely; it became the unknown for me, but an enchanted unknown. . . .

Such estrangement from ordinary reality with its concomitant struggle to express an enchanted unknown was very familiar to Rothko. If it appeared to others that he was repeating a single experience (and many critics stepped forward to remind him of his repetitious composing), to Rothko himself, as to Giacometti, the experience was constantly changing, and never fully revealed—that is to say, never *finally* expressed. Each day he had to begin again. Rothko's respect for Giacometti was based on his recognition of the process that he deemed "tragic." When Rothko spoke about the "tragic" it was not the pathos of tragedy that underlay his thought, but rather, the grand and noble attributes that he had once found in Aeschylus and Shakespeare. It was the tragedy of man's destiny— to be forever caught between birth and death—and aware of the strange disparity between the great space of the imagination and the material human fate. Rothko was always aware that his means fell short of his vision because his means *were* material. In optimistic moments, though, he would exclaim, "They are not paintings."

But he knew, of course, that they were also paintings. He was a modern, after all, and full of disturbing thoughts; full of moments of ambivalence; full of irony. At the time he divested himself of all obstacles and began his journey through the fateful doorway, he knew that painting was his only means. From means to meanings—the longest and most

troubling journey. When he presented his disembarrassed paintings in the early 1950s, everyone seemed worried about meaning. What could it mean if a painter constrained himself to a format of a few rectangular shapes, painted in such a way that even their place in space was ambiguous? What framework of thought could embrace these slightly pulsating visions? Were they merely decorative, meant for delectation only? Was he, as one critic suggested, capable of uttering only a single note? The answer for Rothko, and for those who could respond vividly to the presence of such paintings, was very much as Sartre had said about painting in general: the paintings don't *mean* anything, but they have meaning. When Rothko said he looked forward to the day when an artist was evaluated for the meaning of his life's work, I think that is what he meant.

On paper or on canvas, Rothko used paint to suggest a multiplicity of experiences—experiences of space and light and shadow and silence that could not be paraphrased in written language. Or, if they could be captured in the word, they would be as condensed as a poet's most arcane metaphor. With breath-taking skill he could set up an expectancy and a process of slow revelation. One area with its raveled edge might hover in the foreground while another, so closely analogous, might sink behind slowly, as a late afternoon shadow dies. At the same time, there is always a slight, ever so slight, movement within each form that makes a start toward a destination. Or at least initiates a covert motion that draws the viewer into the depths of Rothko's image. But the depths themselves are not soundable. The whole question of where the painted shape lies in space—the most basic question in the art of painting—is posed in the most paradoxical terms, for Rothko, as he himself said, was not working with space as such. He conjured light and he conjured shadow, as painters have always done, but he did so in the service of an ideal that transcended both, and that can only be felt and not thought. It is in such painterly equivocation that Rothko's power lies, for he lures his viewer into an expectation of what he himself always awaited: a moment of revelation. Equivocation—all those slipping planes, those quivering tympanums, those haloed whites, those shimmering crimsons, those near-blacks and near-purples—gave back so much that had been banished from painting: a chance for metaphor, a chance for indeterminate, floating feeling, a chance for mystery.

As Rothko had moved through his painting life toward clarity, he sometimes doubted, and even his doubts became a part of his enterprise. He was dubious about the world of men and questioned human sagacity. Yet he did not permit himself to slip over into the climate of the mystic. Rather, he hoped to wring miracles from his own depths, from his material existence. He could believe in the efficacy of the symbolic image, brought to the surface of his paintings. He had brought himself to the same plateau on which Nietzsche stood in his mature period when he remarked in *Ecce Homo*:

The involuntary nature of image, of metaphor, is the most remarkable thing of all; one no longer has any idea what is image, what metaphor, everything presents itself as the readiest, the truest, the simplest means of expression.

MARK
ROTHKO
WORKS ON
PAPER

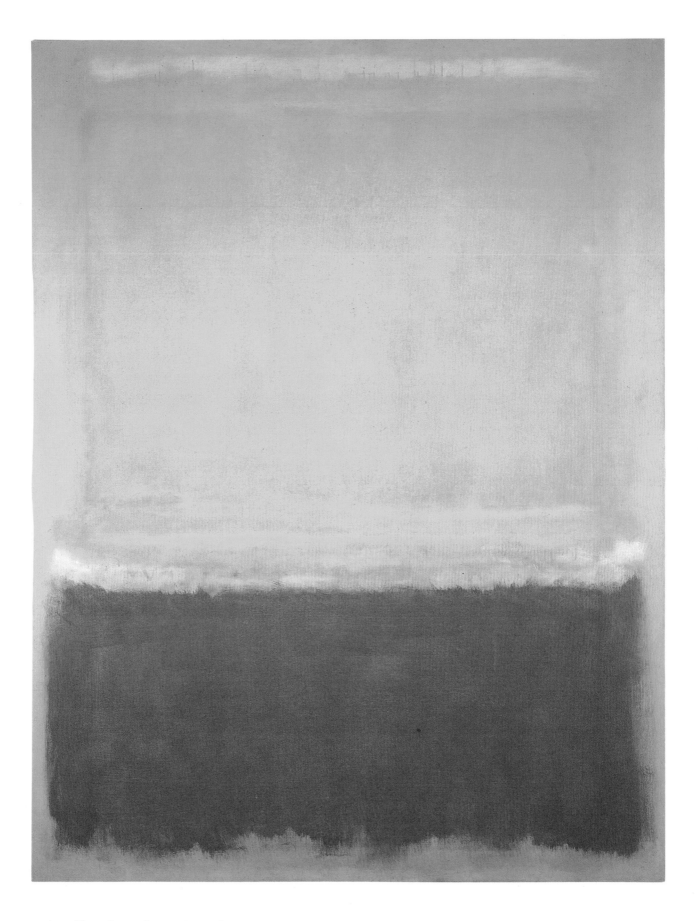

Mark Rothko. *White, Yellow, Red on Yellow,* 1953
Oil on canvas
7 ft. 6¾ in. x 5 ft. 11 in.
Collection Donald B. Marron, New York

B Y 1950 Mark Rothko had evolved the style of painting that was to win him acclaim and establish him as a twentieth-century master. In his classic paintings Rothko stacked two or three rectangles of glowing color on large stained canvases. However, throughout his career he produced many lesser-known works on paper which share characteristics with his canvases while exhibiting their own special qualities. These works, which until now have received little attention, are essential to a fuller understanding of Rothko's career. Together with the canvases, the works on paper chart the artist's quest for an elemental language that would communicate basic human emotions and move all mankind.

In many respects Rothko may be considered to have been a self-taught artist. Russian-born Marcus Rothkowitz (1903-1970) had little opportunity to study art during his youth in Portland, Oregon. Art as a career was not encourged by his immigrant family, but Marcus did not give them much reason to be concerned for his future. He showed a particular interest in literature, music, and social studies and excelled scholastically. Even while on scholarship at Yale University from 1921 to 1923 he showed no predisposition toward an artistic career. He left college in his junior year and after a period of aimless drifting around New York and a few trips West he decided to enroll in several courses at the Art Students League. His sampling of courses at the Art Students League, among them Max Weber's painting class, constituted his only formal training in art. Weber had studied in Europe and absorbed the lessons of the early modern pioneers. He developed a personal form of Cubism in the teens and exhibited alongside Matisse, Picasso, and Kandinsky. By the time Rothko studied with him, Weber had evolved a more representational style strongly imprinted with Cézanne's influence. From Weber's early writings on art theory we can deduce what might have impressed his young student. In 1916 Weber had written:

> A color must be more than a color. A form must be more than a form; it must suggest the sacred more only found in the spiritual. Everything must be more than it is visibly.[1]
>
> We must study the antiques. And the more we do so the better are we able to discern the new of to-day, even if the intent differ greatly from the art of the past.[2]
>
> Matter is merely matter; it lies and knows not. Matter inbreathed with spirit, moves and transcends; it illumines darkness, and fills emptiness, and enlivens even the vacuous.[3]

Rothko also learned by visiting art exhibitions and other artists' studios and it was primarily through these experiences that he was exposed to the watercolor and gouache

Max Weber. *Zinnias,* 1927
Oil on canvas
28 x 20½ in.
The Newark Museum Collection
(Gift of Mrs. Felix Fuld, 1928)

Milton Avery. *Sun Worshippers,* 1931
Oil on canvas
26 x 33 in.
Yares Gallery, Scottsdale, Arizona

mediums. Among the determined and dedicated artists with whom he associated was Milton Avery. Avery's simplified forms and flat areas of color offered an alternative to Weber's heavily painted canvases. In the late twenties and the thirties Rothko and his colleague Adolph Gottlieb visited Avery's studio almost daily. They even summered with the older artist and his wife, Sally, in Cape Ann, Massachusetts, where they spent days on the beach painting watercolors and gouaches. Avery's commitment to his work was particularly inspiring to the two younger men, and although Rothko seldom lauded another artist or acknowledged any influences, in the memorial address he delivered for Avery in 1965 he revealed his respect for the late artist:

> I cannot tell you what it meant for us during those early years to be made welcome in those memorable studios on Broadway, 72nd Street, and Columbus Avenue. We were, there, both the subjects of his paintings and his idolatrous audience. The walls were always covered with an endless and changing array of poetry and light.
>
> There have been several others in our generation who have celebrated the world around them, but none with that inevitability where the poetry penetrated every pore of the canvas to the very last touch of the brush. For Avery was a great poet-inventor who had invented sonorities never seen nor heard before. From these we have learned much and will learn more for a long time to come.[4]

Mark Rothko. *Sketch in the Shade,* July 1925
Oil on canvas board
17⅞ x 16 in.
(P 7)

Mark Rothko. Untitled, late 1920s
Oil on canvas
17⁷⁄₁₆ x 14⅝ in.
(P 8)

Rothko's earliest works, from the mid- to late twenties, consist of expressionistically rendered landscapes, genre scenes, still lifes, and bathers painted in a style combining characteristics of Cézanne, Weber, and Avery. In these early canvases Rothko generally avoided perspective, choosing instead a shallow picture plane. One of his first oil paintings is the verdant landscape *Sketch in the Shade* of July 1925. He seems to have been determined to cover this canvas board completely with thickly applied green, yellow, and blue paint. Generally, Rothko's early canvases rarely display such heightened tones. The muddy colors of the portrait of a woman are more typical of his initial attempts. These early canvases have the appearance of student work and are not as accomplished as his contemporary watercolors (Plates 1, 2), which already demonstrate a masterful handling of color and a dextrous application of thin washes of pigment. Figures and countryside emerge from crisply applied dots and dashes and diaphanous masses of color which loosely follow the graphite underdrawing. Rothko experimented with a variety of mediums on paper, using his materials in innovative ways. Black show card (poster paint) was a favored medium during these early years (Plate 3); with it he achieved strong contrasts of light and dark by applying the undiluted black paint to linen-textured white paper. Occasionally he scored the stained surface with a razor blade to alleviate the density of blackened areas or to model forms. The black paintings on paper are perhaps

his most spontaneously conceived early creations, produced without benefit of preparatory sketches or underdrawing.

Rothko's first one-man exhibition, which was held in the summer of 1933 at the Portland Museum of Art, was composed exclusively of works on paper. The reviewer for the *Sunday Oregonian* wrote of the works of Portland's former resident:

> The water colors are chiefly landscapes and studies of forests in which the artist has sought to retain the effect of complexity one finds in the out-of-doors and to show its ultimate order and beauty. A hint of his admiration for Cezanne is in these water colors. They are carefully thought out and in no way theatrical or dramatic, as are the temperas which were spontaneously conceived and executed and which depend upon the richness of their blacks against white for effect. Those who admire the rich and velvety quality of the temperas will be mildly surprised to discover that the artist combined only black water color or show card, the sheets from a 10-cent tablet of linen writing paper, with his own skill to get the desired effect.[5]

However successful these watercolors, at the time of the Portland exhibition Rothko declared that he preferred oil on canvas to all other mediums.[6]

Rothko was an avid draughtsman during the thirties. His art was rooted in reality and the entire city was his model. The large number of extant sketches on small pieces of paper reveal that Rothko constantly carried with him pads of paper, sketching his friends, city blocks, and subway riders. The subjects of these quick ink and pencil line drawings often found their way into finished paintings after he reworked them in numerous preparatory sketches. Although the initial sketch was usually from life, in the preparatory sketches Rothko would exaggerate and stylize the figures and place them in ambiguous space. He compulsively reworked and refined the sketch, and it is not unusual to find twenty studies for a single painting. These sketches were primarily drawn with pencil or pen and ink, but he also produced color studies using tempera paint on colored construction paper (Plate 4). Adolph Gottlieb also painted on colored construction paper during these same years. In a 1967 interview Gottlieb disclosed that Avery had encouraged him to experiment with the dime-store stock.[7] Most likely, Rothko, like Gottlieb, was stimulated by Avery's example. Mystery and dread permeate these tempera paintings on paper. The figures, originally taken from life, have been transformed into tragic beings who haunt the subway platforms, claustrophobic apartment rooms, and urban canyons of Rothko's city. The temperas, often muddied by the colored background, are in tones reminiscent of urban grime and soot. Cued by Avery and Matisse, Rothko bathed the faces of these figures in unnatural tints of chartreuse, pink, and yellow. But unlike these artists, Rothko used color to contribute to the eerie, tense mood of his paintings on paper. Rothko considered many of these tempera studies as finished works of art and during the thirties he often matted and exhibited them. In later years he apparently wanted these works to be identified as his creations; if the work was originally signed "Rothkowitz" he erased the ending, while he would inscribe "Rothko" on unsigned works.

When he was finally satisfied with the compositional sketch, he transferred it to canvas, sometimes using a grid to assure the exact re-creation of the sketch on canvas

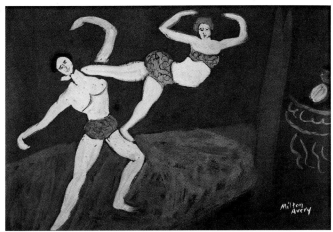

Mark Rothko. Untitled, 1930s (above left)
Pen and ink on paper
7 x 5 in.
(Sketchbook II, 9F)

Milton Avery. *Acrobats,* 1931 (above)
Gouache on black paper
12 x 18 in.
The Eason Gallery, Santa Fe, New Mexico

Mark Rothko. *Street Scene,* 1930s (left)
Oil on canvas
36 x 22 in.
(3106.30)

(Plate 5). The image continued to evolve on the canvas and occasionally Rothko duplicated the same composition on more than one canvas. This practice was partly fostered by his employment on the WPA Federal Art Project where, as a participant in the easel division, he was required to produce paintings each month for federal buildings. By duplicating his compositions, Rothko, who was attached to his works, could more willingly surrender one copy to the government. However, the repetition of the composition on more than one canvas may also be viewed as the continuation of the refining process begun in the multiple preparatory sketches.

Because sales of his paintings during his formative years were rare, Rothko sought employment as a part-time art teacher at the Center Academy of the Brooklyn Jewish Center. Although his first wife, Edith Sachar, whom he married in 1932, was a relatively successful designer of costume jewelry, Rothko continued to teach at this experimental progressive school in order to contribute to the couple's upkeep. Rothko's teaching at the Center Academy from 1929 to 1952 was pivotal in the crystallization of his aesthetic ideas. In his notes on art education written in the late thirties he set down his thoughts on color, form, scale, and mediums.[8] Some of these theories influenced the course of his career. Rothko's observations were informed by the writings of art educators, notably the Viennese teacher Franz Cizek, whose pioneering theories were published in English in 1936 and from which Rothko quoted extensively.[9] Rothko agreed with Cizek's contention that all children unconsciously follow eternal laws of form. He also adopted Cizek's method of teaching, which was "to let children grow, flourish and mature according to their innate laws of development, not haphazardly."[10] According to Cizek, "The unspoiled child . . . knows no perspective. Perspective is a matter of geometry, as anatomy is a matter of medical science. . . . Why does the work of the primitives appear to us so strong, despite the lack of perspective? Why do the works of the ancient Egyptians appear to us so strong? Because they are created according to the same laws as children's drawings."[11] The analogy between children's art and primitive art impressed Rothko, and in his notes he discussed this analogy, as well as the relationship between children's art and modern art. Cizek's theories on primitivism and the innate laws of children's art, along with Rothko's own close contact with his young students, helped prepare him for the first major transition in his work, in which children's art, ancient art, and the art of the Surrealists would play a major role. Although he was still painting urban scenes when he composed his treatise, Rothko was already searching for an elemental language. Perhaps he anticipated the fulfillment of Cizek's prophecy that "in the place of present-day art an entirely new art will come into being. And this new art will reflect the immense changes of our time and will express the desires and longings of the period."[12]

DURING the early forties the artist changed his name from Rothkowitz to Rothko, divorced his first wife and married his second, and, along with Adolph Gottlieb, abandoned Depression-era realism in his exploration of Surrealism and mythic imagery.[13] Rothko's and Gottlieb's interest in myth was shared during this same period by

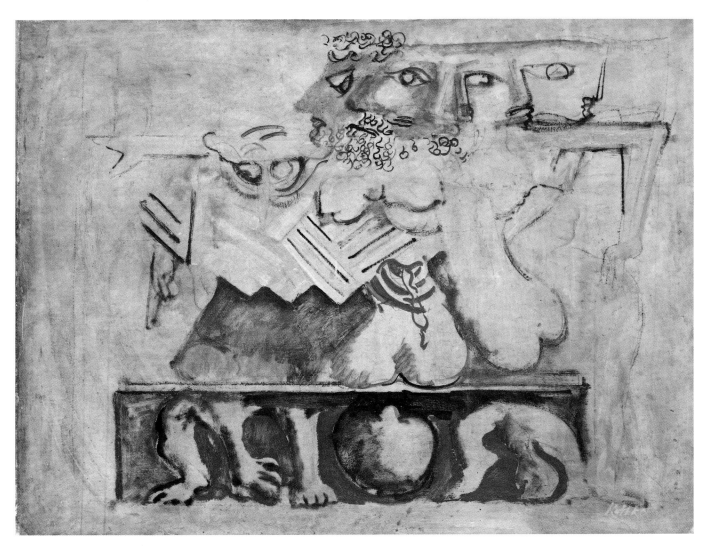

Mark Rothko. *Antigone,* early 1940s
Oil on canvas
34 x 45¾ in.
(3240.38)

other members of what would become the New York School. As Gottlieb related in later years, "The interest in myth was in the air."[14] Carl Jung's theories on the collective unconscious, which the artists read or absorbed through discussions with their colleagues, colored much of their thoughts on myth. They were not concerned with myth for its romantic flavor, or for its association with a lost arcadia. Myth expressed something real, universal, eternal. The realistic rendering of myth held no interest for Rothko or Gottlieb. Although Rothko titled his works *Antigone, The Omen of the Eagle, Sacrifice of Iphigenia,* he stressed that he was portraying not particular incidents from ancient myths, but the universal "Spirit of Myth."[15] As he explained: "If our titles recall the known myths of antiquity, we have used them again because they are the eternal symbols upon which we must fall back to express basic psychological ideas. They are the symbols of man's

primitive fears and motivations, no matter in which land or what time, changing only in detail but never in substance. . . ."[16] In a letter to the *New York Times* art critic Edward Alden Jewell, Rothko and Gottlieb offered their credo:

1. To us art is an adventure into an unknown world, which can be explored only by those willing to take the risks.

2. This world of the imagination is fancy-free and violently opposed to common sense.

3. It is our function as artists to make the spectator see the world our way—not his way.

4. We favor the simple expression of the complex thought. We are for the large shape because it has the impact of the unequivocal. We wish to reassert the picture plane. We are for flat forms because they destroy illusion and reveal truth.

5. It is a widely accepted notion among painters that it does not matter what one paints as long as it is well painted. This is the essence of academicism. There is no such thing as good painting about nothing. We assert that the subject is crucial and only that subject matter is valid which is tragic and timeless. That is why we profess spiritual kinship with primitive and archaic art.[17]

These new subjects demanded new images and a new style. Gottlieb's solution for his pictographs was to divide his canvas into compartments, similar to those used in Medieval

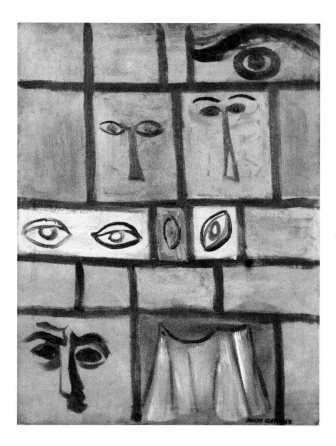

Adolph Gottlieb. *Oedipus,* 1941
Oil on canvas
34 x 26 in.
Adolph & Esther Gottlieb Foundation, New York

and Renaissance narrative cycles, in which he situated personal symbols. Rothko populated the cramped interiors of his mythic paintings with composite figures of human, animal, and plant forms. Crushed by the shallow picture plane, the forms are flattened into an Archaic frieze. Simple thick lines usually define the figures, while the curly locks sprouting from the collective heads and chins of these grotesques seem chiseled by some ancient sculptor's hand.

The multiplicity of heads and limbs, the fracture of the bodies, and the division of the canvas into horizontal registers may have been inspired by Rothko's knowledge of Cubism and of naïve and African art. However, the mutilation of the figures is perhaps a reference to the myth of Dionysus. Rothko claimed that the writings of Friedrich Nietzsche made a strong impact on him and it may have been the nineteenth-century German philosopher's interpretation of the Dionysus myth to which he alluded. As a boy Dionysus was torn to pieces by the Titans. "Thus," wrote Nietzsche,

> it is intimated that this dismemberment, the properly Dionysian *suffering,* is like a transformation into air, water, earth, and fire, that we are therefore to regard the state of individuation as the origin and primal cause of all suffering, as something objectionable in itself. From the smile of this Dionysus sprang the Olympian gods, from his tears sprang man. In this existence as a dismembered god, Dionysus possesses the dual nature of a cruel, barbarized demon and a mild, gentle ruler.[18]

In addition to these truncated figures, the masklike faces of the mythic paintings make further allusion to *The Birth of Tragedy* where Nietzsche states:

> The tradition is undisputed that Greek tragedy in its earliest form had for its sole theme the sufferings of Dionysus and that for a long time the only stage hero was Dionysus himself. But it may be claimed with equal confidence that until Euripides, Dionysus never ceased to be the tragic hero; that all the celebrated figures of the Greek stage— Prometheus, Oedipus, etc.—are mere masks of this original hero, Dionysus.[19]

In Rothko's mythic paintings Dionysus assumes the mask of another "tragic hero," that of Christ (Plate 8). Since Early Christian times Dionysus has been considered a pagan precursor of Christ. Some of Rothko's drawings and canvases of this period graphically depict the suffering of multi-headed martyrs. In one canvas the martyred masked group is contrasted with a more naturalistically rendered crucifixion of an anonymous headless victim which occupies a separate compartment on the right. It is possible that this painting is an illustration of Nietzsche's statement, with the single figure representing the original hero, the grouped figures merely the masks of the deity.

Viewers, finding the mutilations incomprehensible, recoiled from these new paintings. According to Rothko, those who were horrified by the mythic paintings were responding appropriately. He justified the grotesque appearance of his figures in an early

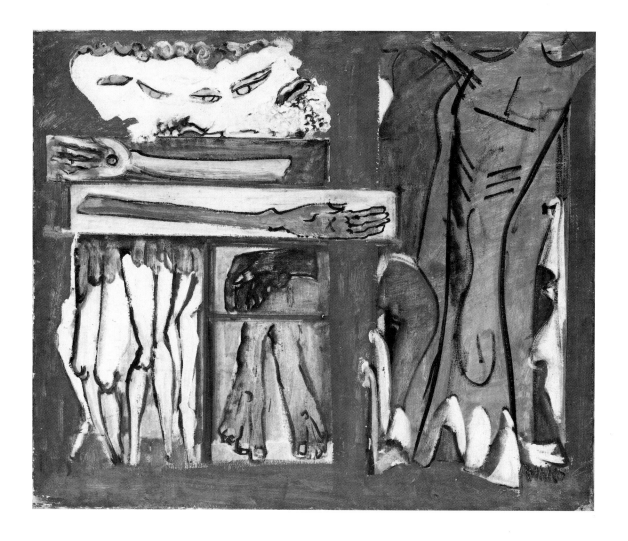

draft of the letter to *New York Times* art critic Edward Alden Jewell mentioned above. In his draft, which predates Gottlieb's involvement, Rothko explained:

> Any one familiar with the evolution of modern art knows what potent catalyzers Negro sculpture, and the art of the Aegean were at its inception. Ever since this inception the most gifted men of our time, whether they seated their models in their studios, or found within themselves the models for their art, have distorted these models until they awoke the traces of their archaic prototype and it is their distortion which symbolizes the spiritual force of our time.
>
> To say that the modern artist has been fascinated primarily by the formal relationship aspects of archaic art is, at best, a partial and misleading explanation. For any serious artist or thinker will know that a form is significant only insofar as it expresses the inherent idea. The truth is therefore that the modern artist has a spiritual kinship with the emotions which these archaic forms imprison and the myths which they represent. The public therefore which reacted so violently to the primitive brutality of this art, reacted more truly than the critic who spoke about forms and techniques. That the public resented this spiritual mirroring of itself is not difficult to understand.[20]

Mark Rothko. Untitled, early 1940s
Oil on canvas
30 x 36 in.
(3082.39)

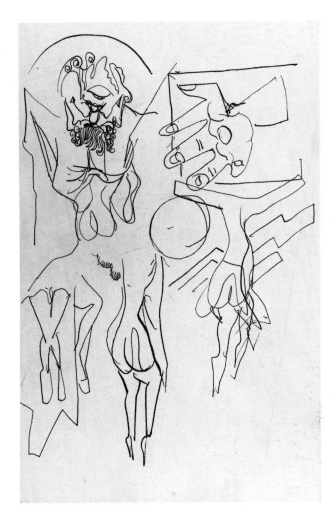

Mark Rothko. Untitled, early 1940s
Pen and ink on paper
9 x 6 in.
(H6.9)

Rothko planned his myth paintings carefully and relied heavily on drawings and preparatory sketches. Like his works on paper of the thirties, many of these sketches were drawn with pencil or pen and ink. He also produced a few watercolor and tempera paintings on paper which are related to the canvases. In several of the sketches Rothko worked on isolated forms, such as a torso or hand, or a combination of a few elements, which were subsequently incorporated in the compositional sketches. Rothko would transfer the perfected sketch to canvas, where the composition continued its metamorphosis. The changes in the composition are usually visible, as the initial charcoal sketch and early painted outlines peep through the paint film. The compositional sketches are often valuable guides to deciphering the images on the canvases. For example, the watercolor sketch for *Antigone* (Plate 6) reveals that the chevrons on the figure on the left side of the canvas were meant to suggest ribs. The green frame in the study, which is absent on the canvas, connects the work with other compositions from the period in which the artist enclosed his figures in an architectural niche.

Around 1943 Rothko began to substitute personal myths for antique themes. The presence of the European Surrealists living in New York during World War II and the

accessibility of their work played a significant role in Rothko's evolution and that of his colleagues. The Surrealists' central technique of automatism and their biomorphic shapes in particular influenced the New York artists' approach to their own work. Whereas Rothko's earlier mytho-classical paintings depict recognizable though grotesque figures, the organic forms of his Surrealist paintings approach abstraction. These paintings, in which biomorphs seem to float, swirl, and gyrate in front of horizontal planes of color, reveal a more spontaneous Rothko relying on his subconscious for inspiration. Yet he was still reluctant to sever his ties with reality and enter the world of abstraction, as he explained in 1945:

> I love both the object and the dream far too much to have them effervesced into the insubstantiality of memory and hallucination. The abstract artist has given material existence to many unseen worlds and tempi. But I repudiate his denial of the anecdote just as I repudiate the denial of the material existence of the whole of reality.[21]

Nevertheless, he felt that the dramatic mood of his realist and mythic paintings could be expressed only by means of abstract forms. In later years he reflected that "it was with the utmost reluctance I found the figure could not serve my purposes."[22]

Watercolor became increasingly important to Rothko during his Surrealist phase and he conceived these watercolors as finished works of art. Although the Surrealist watercolors appear to be the result of pure automatist creation, Rothko felt the need to structure his compositions. In most cases he first drew his design with pencil and ruled the horizontal divisions, but even the underdrawing cannot be considered automatist creation, since the compositions of many of these watercolors appear to be modeled after some of his mythic paintings. Such watercolors as Untitled, 1944-45 (Plate 13), suggest that the artist was looking at his mythic painting *Antigone* when he drew his composition. Although the conglomerate figures of the mythic painting have been reduced to almost skeletal form in the Surreal watercolor, many of the basic elements remain. The multiple figures of *Antigone* are divided by two strong horizontal lines—the first composed of the shoulders and the raised arm that terminates in the pointing finger, the second created by the bench that supports them. Another division is suggested across the middle, where the light zigzag interlocks with its darker mate. The watercolor is also divided horizontally into four planes, although the middle plane is more clearly defined here than in the canvas; and the pointing finger of the *Antigone* is replaced in the watercolor by a directional arrow on the left. Other elements common to both watercolor and mythic painting are: the curved black lines that echo the shape of the bent elbow and the jutting hip of the figure on the right; the "bow-tie" rendering of the breasts of the central figure; the two round circles of the figure on the extreme left which balance on the top horizontal line; and the vertical form on the left descending from the shaft of the arrow which recalls the second pointing finger occupying a similar position in *Antigone*. This composition was repeated in a multitude of watercolors during the mid-1940s. Rothko did not, however,

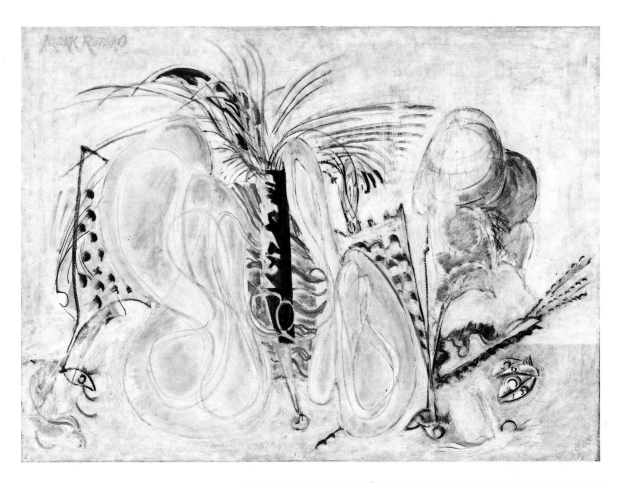

Mark Rothko. *Birth of Cephalopods,* 1944/45 (top)
Oil on canvas
39⅝ x 53¹¹⁄₁₆ in.
(3058.44)

Mark Rothko. *Horizontal Procession,* 1944/45 (bottom)
Oil on canvas
24¼ x 48⅛ in.
(3030.40)

slavishly follow the original sketch for, as he explained, "Neither the action nor the actors can be anticipated, or described in advance. They begin as an unknown adventure in an unknown space. . . . Ideas and plans that existed in the mind at the start were simply the doorway through which one left the world in which they occur."[23]

Rothko evolved a personal watercolor technique during his Surrealist years. Using generous soft-bristled brushes, he applied the watercolor, gouache, and tempera to a good quality watercolor paper. Before the paint dried, he would return with black ink in order to define forms or to gesture automatist lines. When introduced into areas still wet with paint, the ink would bleed, resulting in the black bursts that spot some of these works. Often Rothko dabbed watercolor in pointillist fashion onto one of the horizontal planes, and occasionally he introduced charcoal into his paint, creating velvety opaque passages. As a final step he would frequently scratch and gouge the paper with a razor blade, the back of a brush, or some other sharp implement, exposing the white paper beneath the pigments.

As one might expect, a symbiotic relationship developed between Rothko's two mediums during the forties. He usually drew the composition on his canvases just as he had done for his watercolors; however, the canvases are usually more restrained in appearance and less spontaneous than the watercolors. Watercolor does not lend itself to overworking as does oil paint and Rothko often took advantage of the flexibility and opacity of the oil medium to refine his image on canvas. Still, he began to use oil as if it were watercolor, thinning the medium and applying it in overlapping glazes. On these canvases line is calligraphic, whereas the watercolors, with their roughened surface, exhibit a tactile quality usually associated with oil painting. At times Rothko accumulated such a build-up of fibers by rubbing into the paper that the watercolors have an impasto effect. He enjoyed working with watercolor and in later years remarked that he could have

been a great watercolorist.[24] Certainly his familiarity with the medium influenced the fluid painting technique and atmospheric effect he developed in his classic canvases.

In the spring of 1946 the Mortimer Brandt Gallery held the first exhibition of Rothko's watercolors since his 1933 one-man show at the Portland Museum. One reviewer of the exhibition wrote:

> An archaic note is sounded in many of the pictures and is indeed indicated title-wise in several such as *Ancestral Imprint.* Here a bird-like form soars through space. *Omen* achieves depth through a byplay of greys and whites and a piercing red accent. Throughout the exhibition one senses the artist's compositional integrity, and his muted color provides a happy relief from the violent pigmental expression indulged in by so many who seem to confuse the strident with the brilliant.[25]

Another reviewer observed that the watercolors "recount and evoke Rothko's lyrical, mythical and metamorphical themes."[26] In this exhibition Rothko showed what were to be his last Surrealist works in this medium. By 1946 he had generally simplified his composition to an isolated form which dominates the paper. His colors, applied in broad strokes, tended toward earth tones—grays, browns, and blacks with flecks of bright red or blue. One of the works shown in this exhibition, *Vessels of Magic,* was purchased by the

Mark Rothko. *Vessels of Magic,* 1946
Watercolor on paper
38¾ x 25¾ in.
The Brooklyn Museum, New York

Brooklyn Museum in 1947. In a letter Rothko wrote to Laurine Collins of the Brooklyn Museum he reflected on the painting:

> Thank you for your kind note about the purchase of my picture, and I wish to tell you that I am delighted to be in the Museum's collection.
>
> As to the picture itself—it was one of five paintings of the same size and shape which were painted almost on the eve of my watercolor exhibition in April 1946. I have looked upon them as a *sort* of culmination of a period of concerted painting in this medium, and am happy that it is one of these which you have acquired.[27]

The years 1947 to 1950 were a crucial period in Rothko's development. Abstraction finally supplanted Surrealism in his paintings, and the large canvas began to dominate his production. The small number of extant works on paper from this transitional period indicates that Rothko concentrated on the production of paintings on canvas. In the 1947 watercolor *Fantasy* the amorphous masses of color abandon the strict geometry of his Surrealist paintings. In the watercolors of 1949 forms are simplified and more unified, and in one work on paper from this year (Plate 23) Rothko incorporated the large rectangles that would become his signature style. In general, these works on paper were created with techniques similar to those seen in the Surrealist watercolors. Rothko still used black ink in these watercolors, but less calligraphically; and although he used sgraffiti in some of the works, their surfaces are less tactile.

It is unclear whether Rothko used preparatory sketches for his transitional canvases. The paucity of works on paper from this period suggests that he did not depend heavily on sketches. Apparently he did abandon his earlier practice of first drawing his composition on canvas. In these canvases of the late forties, Rothko used the brush straight away and allowed the image to take shape directly on the canvas. Drips of paint meandering in several directions indicate that he turned these canvases as he worked — a method probably intended to suppress the unconscious creation of recognizable forms. In the earliest of these abstractions he mixed his paints to a syrupy consistency. But by 1949 he was using the stain technique that characterizes most of his mature canvases.

The new direction in Rothko's work may be partly attributed to his friendship with Clyfford Still. In Still, who lived in New York City during 1945-46, Rothko found a kindred spirit. Still's thickly encrusted fields of color expressed the primal emotion and drama that Rothko sought to achieve in his own work. Rothko introduced Still to Peggy Guggenheim and wrote the essay for the catalogue to Still's exhibition at Guggenheim's Art of This Century gallery in February 1946. Later living on opposite coasts, the two artists corresponded frequently, and Still was instrumental in getting Rothko teaching positions during the summers of 1947 and 1949 at the California School of Fine Arts in San Francisco where Still himself taught. Ernest Briggs, who studied with Still and attended Rothko's courses during the summer of 1949, has discussed the special relationship between the two artists.[28] Briggs noted that at the time "Still and Rothko were very tight and a tremendous stimulus to each other." One incident in particular related by Briggs sheds light on what

Mark Rothko. *Fantasy,* 1947
Watercolor on paper
25½ x 39½ in.
Collection Mrs. Samuel Pisar, Paris

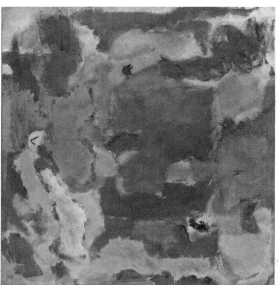

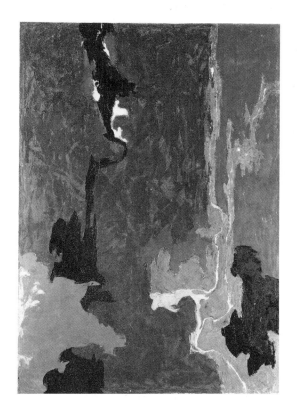

Mark Rothko. Untitled, late 1940s
Oil on canvas
39⅜ x 38½ in.
(3002.47)

Clyfford Still. Untitled, 1946
Oil on canvas
61¾ x 44½ in.
The Metropolitan Museum of Art, New York
(Arthur Hoppock Hearn and George A. Hearn Funds, 1977)

Rothko felt he owed to Still. Rothko had been agitated by an unfavorable review of one of Still's paintings which appeared in the *San Francisco Chronicle*. He gathered a few students together for lunch and suggested that they write a letter of protest. According to Briggs, during lunch Rothko "talked at length in a very passionate manner about how he thought that we should be supportive of Still, and take a position and write a letter. And," Briggs continued, "in that lunch . . . he indicated his debt and great respect and his kind of feeling for Clyfford and his accomplishments. And in his discussion . . . it became clear . . . that he wouldn't have clarified his own ideas without their association." Rothko, Briggs reported, said that Still influenced him in "his attitude of what painting can be" and that he gave him the confidence and courage to put his heart into his work.

P AINTING on canvas clearly had become Rothko's favored medium as the forties drew to a close. Not until the end of his life would paper again play a major role. Understandably, the great proliferation of Rothko's works on paper during his mature period is surprising, since he is thought of as a painter of large paintings. The large canvas first appeared in Rothko's work with his biomorphic painting *Slow Swirl at the Edge of the Sea* of 1944, which measures slightly more than six feet in height and seven feet in width. *Slow Swirl* probably owes its heroic scale to the historical tradition of the big canvas rather than to the ideologies Rothko and the other New York School artists—such as Jackson Pollock, Barnett Newman, Robert Motherwell—formulated in the late forties. For these artists the mural-sized scale of their paintings was not a call for attention, but was integral to the overall effect of their canvases. The critics were initially skeptical of these large paintings and, beginning in the late forties, their reviews of Rothko's exhibitions often focused on the scale of the works. "Rothko is painting them economy-size these days," remarked one critic reviewing the artist's one-man show at Betty Parsons Gallery in January 1950.[29] In the April 1950 issue of *Vogue* the full-page color reproduction of the late transitional painting *Number Eight* was accompanied by the caption, "The One-Picture Wall."[30] In 1951 Rothko explained his reason for painting large:

> I realize that historically the function of painting large pictures is painting something very grandiose and pompous. The reason I paint them, however—I think it applies to other painters I know—is precisely because I want to be very intimate and human. To paint a small picture is to place yourself outside your experience, to look upon an experience as a stereopticon view or with a reducing glass. . . . However you paint the larger picture, you are in it. It isn't something you command.[31]

As the new style of painting gained acceptance, critics began examining and evaluating this "megalomania." Clement Greenberg viewed the big canvas as an attack on the easel convention and as the artists' means of escaping the confines of the picture edge in order to negate the objectness of their paintings.[32] Lawrence Alloway, who associated the big canvas with Edmund Burke's definition of the sublime, wrote, "Still, Newman, and Rothko all paint big pictures. According to Burke the sublime is caused by an astonish-

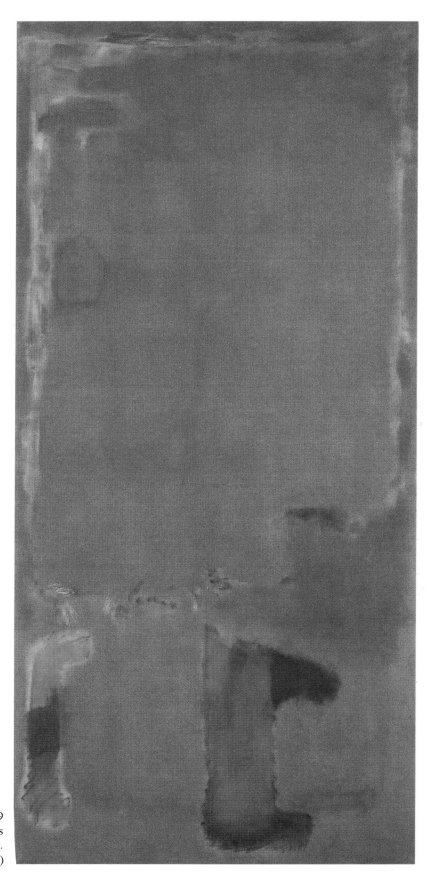

Mark Rothko. *Multiform,* 1949
Oil on canvas
6 ft. 8⅛ in. x 3 ft. 3⅜ in.
(5199.49)

35

ment in which 'the mind is so entirely filled with its object . . . it cannot entertain any other, nor by consequence reason on that object which employs it.' This idea of an art of powerful domination of the spectator indicates something of the effect of the big picture in American art."[33] Other critics remained unconvinced about the large scale of Rothko's paintings. In his review of Rothko's 1961 exhibition at the Museum of Modern Art John Canaday wrote:

> The phenomenon of giantism in contemporary painting may sometimes be only a bid for attention (as it also was in the outsize academic canvases of the nineteenth-century salons). But Rothko is one of those painters to whose art large size is intrinsic, as much as color or any other element—but so increasingly that it begins to take on the character of abnormality, an uncontrollable process that has already gone beyond reasonable limits yet gives no sign of stopping of its own accord.[34]

In defense of Rothko's large canvases Robert Goldwater wrote:

> Small, these pictures would not be the same; therefore they would have to be other pictures. The human scale counts. Granted Rothko's creative obsession, granted his insistence upon a visionary simplicity, and subtlety within that simplicity, scale is the means he has employed to make his pictures both distant and demanding. He has imposed his vision upon us. Is not this what art is for?[35]

Considering the importance of expansive size to Rothko's canvases, one might conclude that working on a small scale challenged him to demonstrate his ideas on the relativity of size. As early as the late thirties Rothko explored the concept of scale. In his notes on art education he explained:

> The scale conception involves the relationship of objects to their surroundings—the emphasis of things *or* space.
> It definitely involves a *space* emotion. A child may limit space arbitrarily and then heroify his objects. Or he may infinitize space, dwarfing the importance of objects, causing them to merge and become part of the space of the world.[36]

At the time he composed these notes, Rothko was incorporating his theories into his art. In the small canvases and works on paper of the thirties, figures assume gigantic proportions as they are wedged between the walls of their cramped apartment interiors. Similarly, the forms of the works on paper from 1950 through 1968 fill up the small space, dominating the composition. Goldwater reported that despite the papers' small size Rothko "saw them as big, both in their effect and in their possibilities, and in discussing them he returned constantly to this question of their implicit size."[37] In an interview with Katharine Kuh the artist admitted, "The pictures have no size—they are exactly the right size for the idea. . . . Which comes first? They're simultaneous."[38] Although the works on paper cannot equal the impact of the large canvases, Rothko often succeeded in achieving monumentality in the smaller dimensions of the paper.

The small works on paper should not be considered miniature Rothkos. Differences exist between these and the canvases which extend beyond scale. Rothko himself remarked that "small pictures are like tales; large pictures are like dramas."[39] Rothko's concern with drama dominated his thinking and, as already mentioned, his ideas may have been inspired by the writings of Friedrich Nietzsche. Nietzsche defined two artistic impulses: the Dionysian, which is the imageless, ecstatic, universal; and the Apollonian, which is the visualized and particularized. According to Nietzsche,

> the aesthetic phenomenon is simple: let anyone have the ability to behold continually a vivid play and to live constantly surrounded by hosts of spirits, and he will be a poet; let anyone feel the urge to transform himself and to speak out of other bodies and souls, and he will be a dramatist.[40]

Rothko assumed the role of the dramatist wishing to communicate to his audience the Dionysian excitement he experienced through his visionary powers. As he explained, "The people who weep before my pictures are having the same religious experience I had when I painted them."[41] No doubt Rothko was heeding Nietzsche's call to "transform Beethoven's 'Hymn to Joy' into a painting"[42] when he claimed that his aspiration was "to raise painting to the level of poignancy of music and poetry."[43] Central to Rothko's aesthetics was the conflict between the Dionysian and Apollonian impulses described by Nietzsche. Dionysus as the essence of tragic art is objectified in the Apollonian and, according to Nietzsche, the Apollonian character often obscures the Dionysian. This imbalance was rectified in Greek drama by the dithyrambic chorus which was responsible for "exciting the mood of the listeners to such a Dionysian degree that, when the tragic hero appeared on the stage, they did not see the awkwardly masked human being but rather a visionary figure, born as it were from their own rapture."[44] As early as 1943 Rothko addressed this conflict between the universal and the particular, when he observed in a radio interview that all great "portraits resemble each other far more than they recall the peculiarities of a particular model. In a sense [artists] have painted one character in all their work. What is indicated here is that the artist's real model is an ideal which embraces all of human drama rather than the appearance of a particular individual."[45] The universal was again emphasized in the catalogue to the artist's one-man show in 1945 at Peggy Guggenheim's Art of This Century gallery in which the anonymous author explained that in Rothko's paintings "the abstract idea is incarnated in the image."[46] By the mid-1940s Rothko, who had been reluctant to abandon the figure, realized that he had to abstract his forms so that his audience would not be trapped by the "awkwardly masked human being" but would see instead the "visionary figure, born . . . from their own rapture." Toward the end of the forties he said of his work:

> I think of my pictures as dramas; the shapes in the pictures are the performers. They have been created from the need for a group of actors who are able to move dramatically without embarrassment and execute gestures without shame.

The presentation of this drama in the familiar world was never possible. . . . The familiar identity of things has to be pulverized in order to destroy the finite associations with which our society increasingly enshrouds every aspect of our environment.[47]

During the fifties and sixties Rothko gave material existence to his ecstatic vision by veiling his large canvas with several layers of luminous color. The lower layers of color radiate through the top layer, which Rothko usually applied with a fluttering brush stroke. The lower layers of color also illuminate the canvas by creating a nimbus around the rectangular forms. As a result of the shimmering and flickering light and the pulsating colors which project and recede, Rothko's canvas seems to be in a state of constant motion, a motion that mesmerizes the viewer. He hoped that sensitive viewers would be transported by his colors and forms to a more spiritual plane where they would share his vision. The comprehension of his canvases, according to Rothko, was enhanced by the appropriate installation, and perhaps it was with the intention of balancing the particular work with the universal ideal that he insisted that his canvases be installed in groups, never individually or with works by other artists. Although each of his paintings is an autonomous work of art, when viewed in a cohesive ensemble the images merge to re-create Rothko's archetype and to obscure individual characteristics. William Seitz was able to report from conversations with the artist that Rothko felt that "Antitheses . . . are neither synthesized nor neutralized in his work but held in a confronted unity which is a momentary stasis."[48] Besides creating an environment for the viewer, the appropriate installation encourages a dialogue between each of the canvases and between the canvases and the viewer. Awed by the surrounding paintings, the viewer unconsciously transforms the particular image into an "ideal" Rothko. As divined by Rothko, the viewer, enveloped in a room of the artist's canvases, becomes an active observer in a metaphysical drama, seeking the imageless and universal in the façades before him.

Rothko's small works on paper do not demand such participation by the viewer. These works have a polished appearance rarely seen in the large canvases. Their singular appearance stems in part from the physical act of painting on a small scale. Working from a closer vantage point with the papers, the artist naturally was able to exercise greater control over both paint and image. However, we might also argue that the small scale forced the artist to conceive the papers with a separate attitude. Often the forms on the canvases are asymmetrical and slightly askew. The asymmetry resulted from Rothko's reliance on his eye to plot out his composition over the great expanse of canvas. Yet this asymmetry may have been intentional, as Thomas Hess observed:

> Rothko approaches the classical, Renaissance problem of achieving the elemental seren-
> ity of symmetry in a way that avoids the paralyzing boredom perfect symmetry aspires to.
> Like Bramante or Piero della Francesca, he asks the riddle: "What is living and stable?"
> and his answer is a balance of equalities disguised by scale and color.[49]

Asymmetry is more noticeable on a small scale, especially when the composition offers few intricacies to confuse the eye. Probably aware of this phenomenon, Rothko, in his

works on paper, placed his centrally aligned forms more exactly equidistant from the edges. In the canvases the large fields served to camouflage fortuitous splatters and drips as well. Rothko preferred to underwork his canvases, giving only a suggestion of his intent and encouraging the viewer to make his own determination. However, the blemishes and pentimenti that contribute to the excitement of the large canvases would be magnified and thus distracting on a small surface. These accidents are conspicuously absent from most of the small works on paper.

The special properties inherent in the materials Rothko used also contribute to the appearance of the works on paper. Thinned pigments blend and bleed with greater subtlety on absorbent paper than on canvas. The paper's fibers soak up the fluid paint, resulting in a surface almost devoid of the artist's gesture. For most of his small works on paper Rothko preferred to stain the surface with only two layers of paint, unlike the canvases which support several glazes of pigment. (The tendency of the thinned pigments to fuse and consequently lose their identity may have discouraged Rothko from applying additional layers of paint.) Those works on paper that are covered with multiple layers of thick paint usually have a plastic sheen rather than an immaterial luminosity. Lacking the overlapping of color, many of these small works on paper look as if Rothko had peeled away the layers of his paintings in an attempt to unravel his own mystery and expose the core of his art. Thus, with their symmetry, tidy execution, and minimal gesture the small works on paper often seem to be more quintessential Rothko than many of his canvases. However, by supplying us with all the information we need instead of giving just a suggestion of intent, Rothko consequently reduced and limited the viewer's role. The papers with their studied perfection often lack the vitality of the large paintings, and their diminutive scale places these works outside the viewer's experience; without the shimmering motion of multiple veils of color, these small works remain earthbound. It would be unfair to judge the works on paper with the same criteria used for the paintings. They should be appreciated for their subtlety, their directness, and what they disclose about the artist's aesthetics. Indeed, the small works on paper are not dramas; they are beautifully spun tales.

Rothko's works on paper of the early fifties, some of which are studies for canvases, reveal his experimentation during the early stages of his classic period. In one work on paper of the early 1950s (Plate 24), color flows into color, screening the paper with elusive forms. In another work from the same period (Plate 25) form is more defined. Here in the two horizontal regions that extend to the paper's edge, black washed over layers of yellow, orange, and lavender contrasts with the translucent film of a delicate lavender hue. This watercolor is related to a magenta and black canvas of 1953. The works are similar in composition and use of color. In both works Rothko contrasts a large black area at the bottom with a lighter purplish area at the top. However, the oil paint is more opaque and the forms on the canvas stop just short of the edge, where the blue stain underneath the forms creates a narrow aura. The composition of the watercolor and the related large canvas is atypical of most of the canvases of the fifties in which two or three centrally aligned rectangles float on a field of color. And, although Rothko used black in some of his

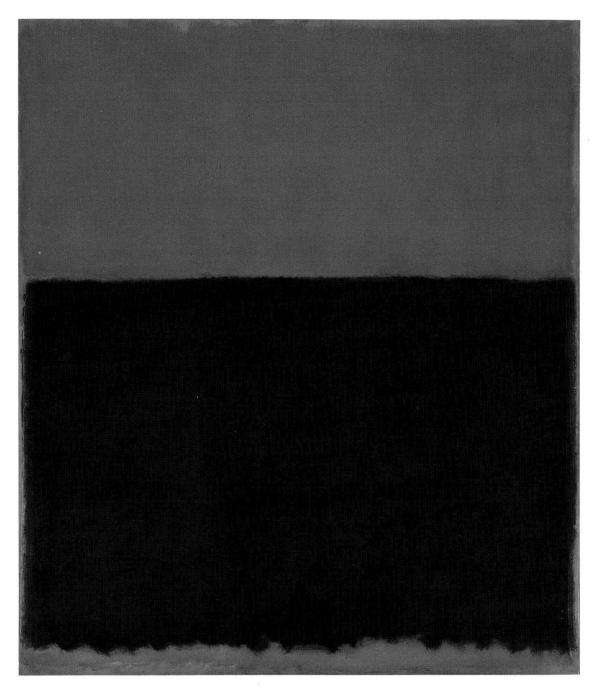

Mark Rothko. Untitled, 1953
Oil on canvas
6 ft. 4^{13}/$_{16}$ in. x 5 ft. 7^{13}/$_{16}$ in.
(5028.53)

canvases of this period, the dark color rarely dominated as much of the composition as it does in the watercolor and in the magenta and black canvas. In fact, the compositions of these works seem to anticipate some of the artist's last works. Rothko's works on paper of the late fifties, however, demonstrate the consolidation of his classic composition. For these works he stained his paper with oil wash instead of watercolor, thus achieving a dry opaque appearance.

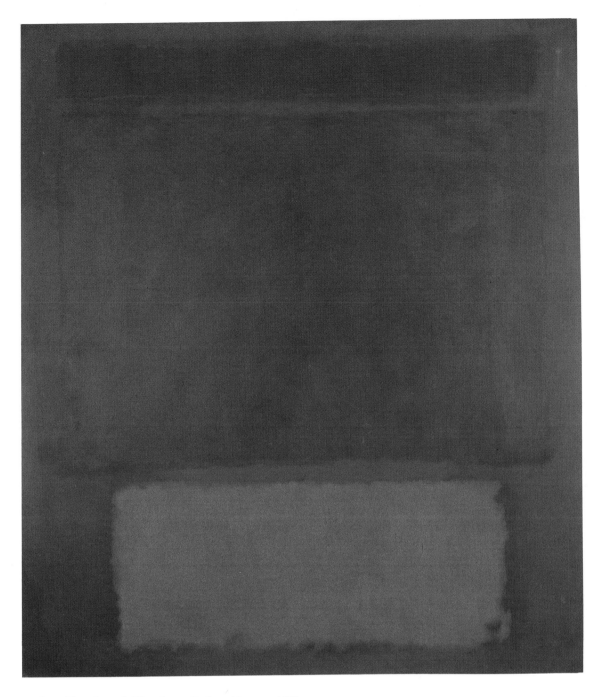

Mark Rothko. *Grayed Olive Green, Red on Maroon,* 1961
Mixed media on canvas
8 ft. 5½ in. x 7 ft. 5¾ in.
(5128.61)

To Rothko the viewer's understanding of his paintings was paramount. He contended that "the progression of a painter's work . . . will be toward clarity: toward the elimination of all obstacles between the painter and the idea, and between the idea and the observer."[50] He had always emphasized that the content of his paintings was more important than their formal elements and stressed that he was not interested in color or form and that he did not consider himself an abstractionist. As quoted by Selden Rodman, color was for him

the vehicle for expressing "basic human emotions—tragedy, ecstasy, doom. . . . And if you, as you say, are moved only by their color relationships, then you miss the point!"[51] Rothko probably realized that his brilliant colors had often obscured his intentions and he decided he must darken his palette in order to avoid decorative connotations. Throughout most of the sixties he restricted the colors of his canvases to brooding tones of deep wine, black, and brown, occasionally infused with fiery passages of red, orange, or flame blue. These dark canvases seem to be illuminated by an inner light source created by the violets and magentas buried deep beneath the blacks, maroons, and browns. Within this limited spectrum Rothko achieved remarkable chromatic nuances that subtly distinguish each form. With his restricted palette and minimal forms Rothko anticipated and seemed to partake in the general reductive approach to art that emerged during the sixties. When Dore Ashton saw the first dark paintings she speculated that Rothko had "struck out with exasperation at the general misinterpretation of his earlier work—especially the effusive yellow, orange and pinks of three years back. He seems to be saying in these new foreboding works that he was never painting *luxe, calme,* and *volupté,* if we had only known it!"[52] Rothko himself revealed to Katharine Kuh his belief that the tragic expression of these dark paintings was more comprehensive.[53]

The development of Rothko's works on paper throughout most of the sixties is not at all parallel to that of his canvases of the same years. While several of the paintings on paper of the sixties display the same narrow range of colors which dominates his canvases of that decade, for the most part these papers continue to glow with the high-keyed pigments of the fifties. Rothko's use of vivid colors on these small works on paper probably was stimulated by the increasingly popular new acrylic and Magna paints.[54] Long after he had committed his canvases to the dark palette, he seemed tempted to test on paper the effect of these intense polymer pigments which could be thinned with water (or, in the case of Magna, with turpentine) without greatly altering the strength of the color. Rothko also may have sought respite from the somber canvases of the sixties by indulging his sensibilities with these new mediums on paper. The colorful works on paper that date from the latter part of the decade in particular offered relief to the artist who had lived for years in the constant presence of his dark, nearly monochromatic murals commissioned in 1964 for a chapel in Houston.

Some of Rothko's papers of the sixties appear to be copies or variations of earlier canvases, and, certainly, repetition played a decisive role in his art. Throughout his career Rothko repeated themes and images on both paper and canvas. In the mature as well as the early works, recurrent themes and images were the result of Rothko's obsessive search for the "essence of the essential." As he revealed to a friend, "If a thing is worth doing once, it is worth doing over and over again—exploring it, probing it, demanding by this repetition that the public look at it."[55] Committed to exhausting all possibilities of his art, Rothko used the small works on paper to perfect his earlier large-scale canvases and to explore slightly different resolutions.

Rothko mounted most of his works on paper on three-dimensional supports. As early

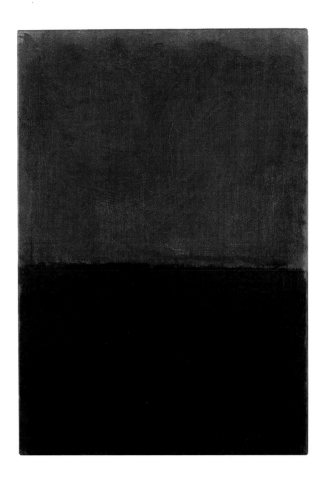

Mark Rothko. Untitled, 1968
Acrylic on paper mounted on Masonite
$32^{13}/_{16}$ x $25^{1}/_{8}$ x $1^{7}/_{16}$ in.
(1189.68)

as the mid-1940s he experimented with mounting his Surrealist watercolors by wrapping them around stretchers or boards. He resumed this practice in the early sixties when he affixed his papers to Masonite. Rothko did not paint on the attached sheets; rather, he sent the finished paintings on paper to John Krushenick for mounting. The approximately one-inch-thick edge of the mount was covered with linen tape which the framer, following Rothko's instructions, painted the same color as the paper's stained field. Most of Rothko's works on paper of the mid- to late 1960s were mounted on stretched linen or canvas by restorer Daniel Goldreyer. The sides of these stretched works, too, were painted by Goldreyer in colors that matched the paper's field.[56] The mounting of these works satisfied several of Rothko's interests. First, it was a solution for exhibiting the works. As with his canvases, he did not want the works on paper framed, and by this method of mounting the papers, hooks or wire could be attached to the backs of the supports, thus eliminating the need of frames. Rothko also hoped that the mounting of the works would increase their longevity. According to Goldwater, "Concerned over their fragility, he began to have the papers mounted on canvas and was glad when he was told that they would last longer and their colors would change less than if painted directly on canvas."[57] Finally, the mounting of these small works contributed to the erosion of the boundaries between Rothko's paintings on canvas and his works on paper which had begun during his Surrealist years. Whereas the large stained canvases have much in common with the water-

color medium Rothko mastered early in his career, the mounted works on paper from the late fifties and sixties have the appearance of stretched canvases. The link between the two mediums is further emphasized by the painted sides of the paper's three-dimensional support which corresponds to the stained tacking margins of Rothko's large canvases. In both the canvases and the works on paper, the painted edges serve to lead the viewer's eye gently out of the painted field.

ALTHOUGH during the sixties Rothko produced works on paper as autonomous works of art independent of his contemporaneous canvases, and normally did not do preparatory sketches for most of his works on canvas of this decade, he did feel the need for sketches in order to work out his ideas for his three mural commissions. Besides recording the evolution of each project, these studies demonstrate Rothko's concern for the appropriate installation of his work. The first of these commissions came in 1958 for the new Seagram Building in New York designed by Mies van der Rohe and Philip Johnson.[58] Johnson and Phyllis Lambert, acting on behalf of her father, the owner of the Seagram company, asked Rothko to produce paintings for an area measuring 27 by 56 feet and gave him carte blanche for the project. Rothko later claimed that when he accepted the invitation he had not known that the murals were intended for the Four Seasons restaurant, and when the project was completed he considered the environment intended for their installation and decided to withdraw from the commission.

Rothko produced three different sets of murals for the Seagram project over a period of eight months. Of the first set, only the painting *White, Black on Wine* has been identified. Although the height of this canvas is approximately identical to most of the later

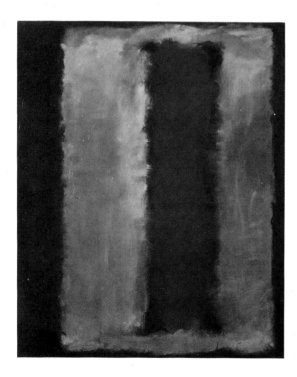

Mark Rothko. *Mural Sketch*, 1959
Mixed media on canvas
72¼ x 60⅛ in.
(5076.59)

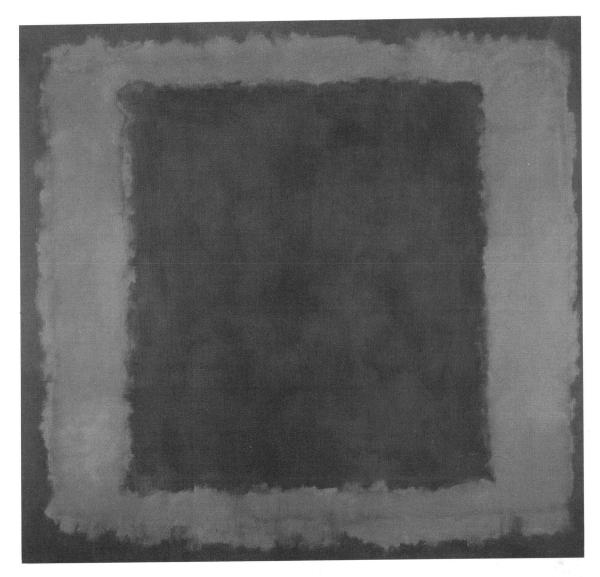

Mark Rothko. Untitled, 1959
Mixed media on canvas
8 ft. 8½ in. x 9 ft. 5½ in.
(6002.59)

Seagram murals, its composition of three stacked rectangles is that of his classic paintings. Rothko, however, was not satisfied with this initial attempt and decided to rethink the composition. For the two successive series he broke away from his characteristic format and substituted single or paired open rectangles on a dark, often maroon field. Most of the mural panels measure eight feet nine inches in height, although the four panels that were to hang over the doors are six feet high and fifteen feet wide. The panels of the second series are composed of a soft-edged form in orange, red, or black, which was applied with frantic brush strokes over a stained field. The canvases of the third group are more heavily painted and their darker, more restrained forms blend with the background. Although he painted small as well as full-size canvas studies for the project, he first tried out the new

Mark Rothko. Untitled (*Mural, Section 5*), 1959
Oil on canvas
6 ft. x 15 ft.
The Tate Gallery, London

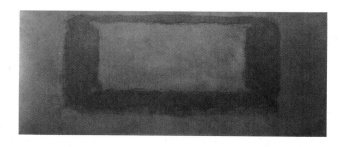

Mark Rothko. Untitled (*Mural, Section 7*), 1959
Oil on canvas
6 ft. x 15 ft.
The Tate Gallery, London

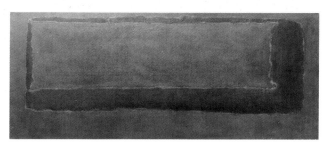

scheme on paper. Of the five existing paper sketches, two are crayon on maroon construction paper, another two are in tempera on maroon construction paper, and one is in tempera on white paper stained deep red (Plates 43, 44). In color and format these paper studies resemble the second series, but they do not seem to be studies for specific works. Rather, they reveal Rothko's initial intentions for the installation of the murals. On narrow strips of paper he depicted individual panels, all sharing the same height and length, joined in a continuous frieze. According to John Fischer, Rothko said that he hoped to achieve a claustrophobic effect with these murals.[59] By linking the murals around the room Rothko probably would have created the feeling that all the exits were blocked and that there was no escape. According to several visitors to Rothko's Bowery studio during the time he was working on the project, he did indeed intend to install the murals in this manner. He had scaffolding erected in the studio in the exact dimensions of the room for which the paintings were intended and he painted and arranged the canvases on this scaffolding. Werner Haftmann, who visited Rothko's studio in the spring of 1959, reported that "at a certain height, there was a darkly luminous frieze of pictures running round the whole room."[60]

In October 1965 Rothko began discussions with Norman Reid, director of the Tate Gallery in London, regarding a large gift of his paintings, which was to include the Seagram mural group. Rothko felt that the Tate was the best museum to house a large group of his paintings. Also, his 1961 retrospective had been warmly received in London, with most of the reviews very favorable. The Tate Gallery had purchased one of his dark paintings in 1959 and was willing to commit gallery space for permanent display of his work. In 1968 Rothko presented *Sketch for Mural No. 6* to the Tate. Rothko and Reid continued to discuss the details of the large gift through January 1969. At that time, however, Rothko decided that he would present only a selection of the Seagram murals to

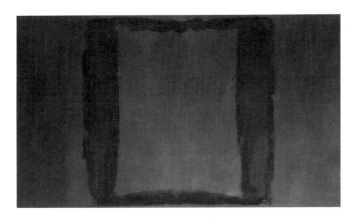

Mark Rothko. Untitled (*Mural, Section 3*), 1959
Oil on canvas
8 ft. 9 in. x 15 ft.
The Tate Gallery, London

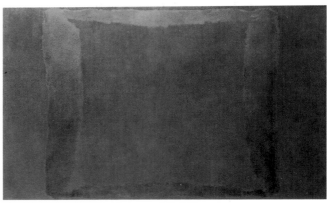

Mark Rothko. Untitled (*Mural, Section 2*), 1959
Oil on canvas
8 ft. 9 in. x 15 ft.
The Tate Gallery, London

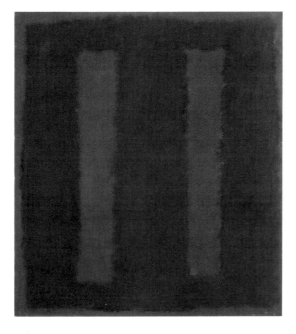

Mark Rothko. Untitled, 1958
Oil on canvas
7 ft. 6 in. x 6 ft. 9½ in.
The Tate Gallery, London

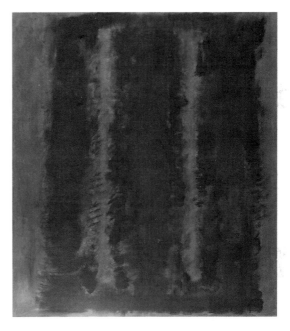

Mark Rothko. Untitled, 1958
Oil on canvas
8 ft. 9 in. x 7 ft. 11 in.
The Tate Gallery, London

the Tate and that the rest would go to his newly formed foundation. He had hoped to go to London in August, but poor health prevented him from traveling. Concerned about creating the appropriate environment with his paintings, Rothko asked Reid to send him a model of the gallery room so that he would have a better idea of what would be a feasible arrangement. In September Reid sent him a plan of gallery 18, and in November he brought him a simple cardboard fold-up model. Together they selected eight of the dark

mural panels and canvas studies to join the mural already at the Tate. This would be Reid's last visit to Rothko's studio.

After the works were selected Rothko painted scaled versions of the murals on maroon construction paper. With just a few strokes of paint he captured the appearance and feel of the canvases. Crisp black and deep-plum lines represent the stark mural panels (Plates 47-50), whereas blurred images suggest the canvas studies (Plates 45, 46). He placed these versions of the murals on the model of the Tate's room in an arrangement that differed considerably from the original frieze concept. Because the Tate selection included the small canvas studies as well as the large panels, the paintings could not be hung with tops and bottoms aligned, as he had originally planned for the installation at the Seagram Building. On the Tate model Rothko glued his miniature murals in groups of similar size and image, and stacked the two narrow murals, an arrangement that was dictated in part by the existing space. In 1961, when the murals were shown at his retrospective exhibition at the Whitechapel Art Gallery in London, Rothko had asked that the paintings be hung high off the floor, explaining: "The murals were painted at a height of 4′6″ above the floor. If it is not possible to raise them to that extent, any raising above three feet would contribute to their advantage and original effect."[61] However, he ultimately decided to hang them relatively low at the Tate, just above the room's wainscoting. The model installation was the closest Rothko would come to seeing his plan realized; the paintings arrived in England on the day of his death.

Rothko received his second mural commission in 1961, from Harvard University, five monumental panels—a triptych and two related canvases—intended for the penthouse of the Holyoke Center. The Harvard murals repeat the composition of the Seagram murals, with the addition of small rectangular protrusions from the horizontal bands which penetrate the central void. Rothko produced numerous tempera studies on colored construction paper for this commission. Although he sometimes painted more than one panel on a sheet, the individual images are not linked as they are in the sketches for the Seagram murals. So far no installation study for the commission has been identified, and it may well be that installation sketches were not necessary because Rothko apparently planned to adhere to his scheme for the Seagram murals. Indeed, the Harvard installation gives a good indication of the effect the Seagram murals might have had in their intended site. Following the Seagram installation scheme, the Harvard murals were hung high off the floor, just above the chairs in the room, and the joined panels of the triptych stretch almost from wall to wall.

Unlike the Seagram mural paper sketches, which seem to be studies for the general scheme of the panels, most of the paper sketches for the Harvard project are studies for specific canvases. The configuration of the center panel of the triptych, in particular, underwent considerable metamorphosis in the tempera sketches. Some of the black tempera on maroon construction paper sketches for this panel show a trio of vertical openings (Plate 56), two on the left and one on the right. In other sketches for the same panel Rothko painted only two apertures, but the vertical column on the left is approxi-

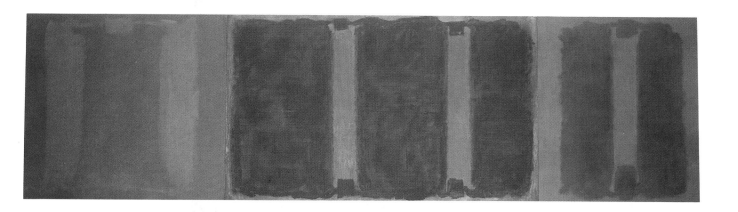

Mark Rothko. Harvard Triptych, 1961
Mixed media on canvas
Left panel 8 ft. 8⅞ in. x 9 ft. 9 in; center panel 8 ft. 9⅛ in. x 15 ft;
right panel 8 ft. 8⅞ in. x 8 ft.
Courtesy of the President and Fellows of Harvard College

mately equal to the combined width of the paired openings that occupy the same location in the previous sketch (Plate 54). He finally settled on the asymmetrical composition with only two openings for the center panel.

Rothko experimented with a variety of color combinations in the paper sketches for the Harvard murals. In one sketch, blue paint was brushed onto green construction paper (Plate 51), while on another, magenta, white, red, and purple tempera cover maroon construction paper. Although Rothko did produce one canvas study for the Harvard murals using iridescent blue and hot red, the definitive set of murals was painted in colors more typical of his paintings of the sixties—black, alizarin crimson, orange, and creamy yellow on deep plum fields. Rothko seemed particularly pleased with the way the tempera paints soaking into the construction paper created blurred shapes, and on the Harvard murals he attempted to simulate this effect with brushy, diffused forms.

Besides the tempera sketches on colored construction paper, Rothko also produced a few pen-and-ink drawings for the Harvard murals. Not since his Surrealist period had he used line to define his forms. On some of these Harvard studies he brushed thin washes of black and red ink, thus creating an atmospheric effect. At about the same time he executed a group of pen-and-ink drawings which were independent of the Harvard project (Plates 59-62). These pen-and-ink drawings, which adhere to Rothko's classic composition, combine washes of black watercolor with cursive automatist lines similar to those in his Surrealist watercolors. Rothko often expressed the desire to produce works similar to his Surrealist paintings, but a return to his earlier style would have been antithetic to his belief in progress. He would have considered it a step backward and he probably thought that the art world would perceive him as regressive. In these few pen-and-ink drawings, however, he was able to incorporate elements from his Surrealist watercolors and yet remain within the limits he set for his art.

In 1964 Rothko was commissioned by Mr. and Mrs. John de Menil to produce murals

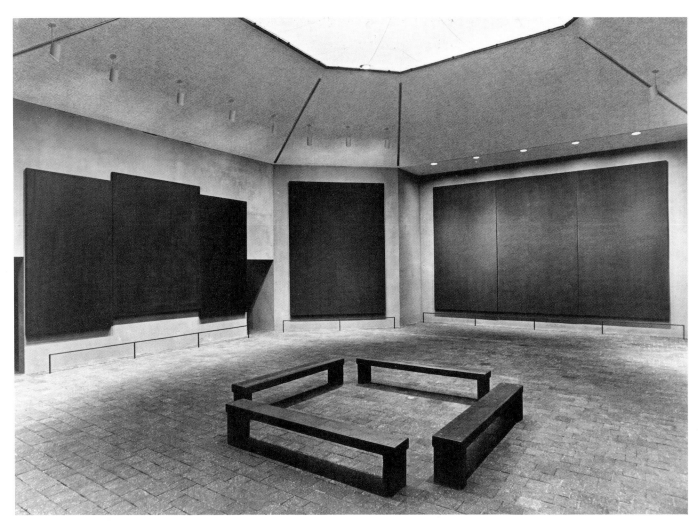

The Rothko Chapel, Houston

for a chapel in Houston. This commission gave Rothko the opportunity to create a total environment, and he filled the octagonal space with dark, meditative panels. The apse triptych and the four panels on the diagonal walls of the octagon are painted entirely with black and violet washes. Each of the two additional triptychs, on the side walls, and the panel on the entrance wall are composed of a single black, hard-edged rectangle on a maroon field. The early paper sketches for the triptychs, probably made in the late fall of 1964, suggest that Rothko originally planned to paint a black rectangle on a field of the same color on each panel. He ruled the outer dimensions of each triptych panel and their interior rectangular forms, which he then shaded with graphite, on black construction paper. Some of the early canvas studies for the chapel follow this configuration. These canvas studies and the graphite drawings are related in color and composition to a series of monochromatic canvases he had painted a few months earlier, in the spring of 1964.

Rothko seemed particularly concerned with the proportions of the panels and he often included his calculations on his graphite sketches. In all of these sketches the top

and bottom edges of the triptychs' panels are aligned. Only the heights and widths of the interior rectangles vary, with the rectangle in the center panel usually raised above those in the flanking panels. The narrow strip ruled at the bottom of these sketches seems to indicate that Rothko intended to append predelle to the bottoms of the triptychs. At least two canvas predelle actually were painted, but he later abandoned the idea.

By the time he began to experiment with the installation of the murals in an early maquette of the chapel, Rothko had already decided to alter the arrangement depicted in the sketches. The top edges of the black construction-paper scale models that are glued to the maquette are no longer at the same level; the central panel, although aligned with the bottom edge of the two adjoining panels, is taller. Ultimately, Rothko decided to raise the center panels of the triptychs on the east and west walls. The apse triptych, with its panels of equal height and tops and bottoms aligned, reflects the original arrangement of the graphite sketches. Rothko worked almost constantly on the chapel commission until 1967. He continued his preoccupation with proportion and changed the dimensions of the monumental canvases and their interior forms several times in his search for the measure that would express the emotional environment he desired. As with the Tate Gallery installation, Rothko never saw his murals for the chapel in place. The chapel was dedicated on February 27, 1971, a little more than a year after his death.

This last commission had opened up new possibilities for Rothko. On New Year's Day of 1966 he expressed his optimism in a letter to the de Menils: "The magnitude, on every level of experience and meaning, of the task in which you have involved me, exceeds all my preconceptions. And it is teaching me to extend myself beyond what I thought was possible for me. For this I thank you."[62] Rothko's use of dense, even blacks, hard-edged borders, and new compositional variations for the chapel murals appears to have influenced the direction of his last works.

AFTER suffering an aneurysm of the aorta in May 1968, Rothko was too weak to attack large canvases and turned almost exclusively to the less strenuous creation of paintings on paper. During the summer of 1968, at his studio in Provincetown, Massachusetts, he began a series of works on paper consisting of combinations of brown and gray. He divided the paper into two horizontal areas, using smooth impersonal brush strokes to apply brown paint to the top half of the work while swathing the bottom with vaporous grays. Unlike his earlier paintings, most of the browns and grays do not float on an expansive field. Immobile, these forms are fixed to the narrow white border surrounding the work. The torn perimeters of some of Rothko's unmounted papers from the fifties and mid-sixties resulted from the hasty removal of the staples and tape he used in order to anchor the paper while he painted and indicate that he intended to crop the edges and mount these works on canvas or Masonite. Toward the end of his life Rothko switched from brown gum tape to masking tape to attach his paper to his easels. The masking tape, which was easier to remove without damaging the paper, created a crisp edge around the image. The white border of the untouched paper, exposed after the removal of the tape,

Rothko's easels for his works on paper

must have appealed to him for it became a characteristic of his late works. This white border creates spatial ambiguities. Acting as a frame or window, the white border sets off the two forms and permits the viewer to gaze deep into the painting, beyond the horizon. Yet the white edge also emphasizes the flat surface of the paper by pulling all the forms within its plane. When we realize that the white is actually the paper underneath the paint, the spatial relationships are further complicated. Once invited to penetrate Rothko's paintings, the spectator is now barred by the shallow pictorial depth and the white border. Although the brown and gray papers are smaller than most of his canvases, they are substantially larger than his earlier works on paper. With them Rothko broke away from the traditional notion that paper is suited only for small-scale work, and thus he further blurred the distinctions between painting on canvas and paper. The drama lacking in the earlier small works on paper is manifest in these larger, more expressively painted brown and gray paintings. In retrospect, we realize that the increased scale of the brown and gray works was part of a general redefinition of working on paper by many artists which began in the sixties and flourished in the seventies.

Rothko worked almost every day during his last year. When his assistant, Oliver Steindecker, arrived at the studio in the morning, the artist would already be painting. Rothko would instruct Steindecker to cut approximately twenty sheets of paper from a large roll which would then be taped onto the easels surrounding the room. Most of the easels were the walls that had been constructed for the chapel commission; he also painted on large plywood panels. Rothko painted very rapidly, and on a good day he could produce fifteen works on paper. Although in poor health, he painted with great energy, moving his whole body, not just his wrist. Some of these works seem to have

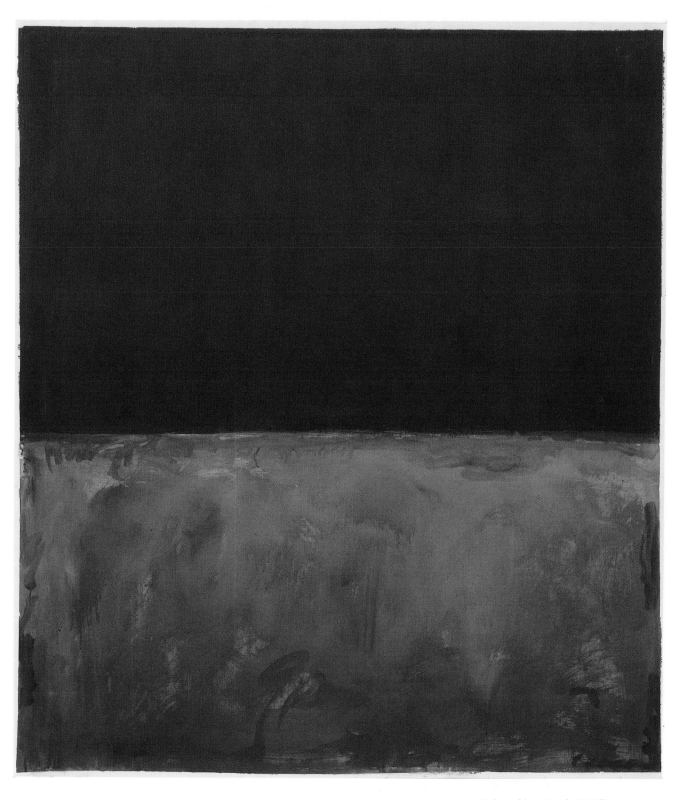

Mark Rothko. Untitled, 1969
Acrylic on canvas
69⅝ x 62³/₁₆ in.
(5212.69)

materialized effortlessly, the grays applied with a single sweep of the brush (Plate 69). Such works contrast with more labored paintings on paper which Rothko could not resist revising and editing. In one work (Plate 67) he originally placed a narrow gray strip at the top of the composition. Later, he decided to paint over the strip with dark umber, integrating it into the brown of the upper region. The alteration of the top of the work demanded a revision of the overall proportions. When he painted over the strip he also lengthened the brown region at the point where it meets the gray. Apparently, the modifications occurred after Rothko removed the tape, as is shown by the paint brushed into the white edge.

Rothko recognized that these works marked a new departure and he showed them to visitors to his studio with great enthusiasm, anxiously awaiting a sign of approval. When Rothko showed Dore Ashton the brown and gray works, "He named the exact number with pride, as though to say 'with all my trouble I was able to do this.'"[63] Irving Sandler recalled that on his last visit to Rothko's studio the artist was concerned over whether people realized that the white border was part of the composition.[64]

In 1969 Rothko began a series of black and gray canvases based on the brown and gray works on paper. Even within this restricted palette there is color in the expressively painted lower region of the canvases with grays ranging from warm ocher to steel blue. The black in the upper area is denser than the brown of the papers and yet a glimmer of light usually glows at the horizon, softening the transition from the opaque black to the brushy gray. The sharply demarcated white edge, here represented by the prepared ground of the canvas, became a major concern for Rothko, and he often adjusted the width of the white to the black and gray several times during a painting's execution. It is possible that Rothko's use of a white prepared ground for these paintings was influenced by his brown and gray works on paper. During the fifties and sixties he had not prepared his canvases with a white ground. Instead, he mixed rabbit-skin glue with powdered pigments to size and stain his canvas simultaneously. In the brown and gray works on paper, the white of the paper is integral to the overall effect, as it lightens the colors of thinly painted areas. Rothko may have been attempting to re-create this effect on his canvases by using a white prepared ground.

Contrary to popular thought, Rothko did not devote himself exclusively to the grisaille series during the last year of his life. Some of his richest color orchestrations appear in little-known works on paper of late 1968 and 1969. The earliest of these are generally painted with thick, waxy layers of Magna, and the forms are usually fashioned in the classic Rothko composition. These overworked surfaces gave way to works of daring iridescence. Velvety black and dark bottle green rectangles eclipse the radiant blue field in Untitled, 1969 (Plate 77), while blinding oranges slashed by a sizzling yellow strip emanate from another work on paper of the same year (Plate 79). Although, as previously noted, Rothko never abandoned bright colors in his works on paper, the late vibrant paintings on paper contain a force not experienced in the earlier small works. The late works on paper are distinguished by the inks that illuminate the paper's field. The inten-

sity of the colors and the smooth leaden forms are novel elements in his works on paper. These late creations, with their dense unmodulated surfaces, do not flicker with light; rather, they generate a strong, constant glow. Rothko probably did not intend to include the white borders of these works in the composition. The late colorful works on paper are closer in composition to Rothko's earlier canvases than to the brown and gray works. The rectangular shapes float on a stained field and do not extend to the white edge as in the brown and gray works. In other paintings on paper of 1969 Rothko superposed thick layers of white, red, terra-cotta, and grayish blue to produce delicate mauves. These papers, usually composed of only two forms—a dark mauve at the top and a lighter variant below which meet at the horizon—resemble in format the brown and gray series. These works are also surrounded by a white edge, but unlike the brown and grays which are held stationary by the white border of the virgin paper, the two regions of the mauves with their soft, scumbled edges usually drift atop a porcelain-tinted field. With their multiple layers of muted hues, white highlights, and flecks of red and blue, the mauve paintings on paper appear opalescent beside the subdued brown and gray works.

In a few works on paper of 1969 Rothko experimented with unusual forms, as reported by the author Bernard Malamud, who visited Rothko's studio in the early winter of 1969. According to Malamud, one of the works was "a black rectangle, about two feet by three, the black broken by a three or four inch jagged section in bright aquamarine. The aquamarine looked like light breaking through night. It was an uneven form, perhaps zigzag, unlike anything I'd seen in his work."[65]

The richly chromatic works on paper of late 1968 and 1969 inspired Rothko to reintroduce bright color to his canvases. The first of these canvases was influenced by the dark greenish black and brilliant blue papers. These papers compete in size with the canvas, and one work on paper in these colors, measuring seven feet by four and one-half feet, actually dwarfs the painting. Rothko attempted to duplicate the effect of the papers on the canvas with a bright blue field supporting two rectangles of dark green brushed over black. As on the papers, brush strokes are minimized, the surface smooth. However, Rothko was unable to capture on canvas the radiance of the blue and black papers which results from light reflecting off the white paper and through the translucent ink.

The surface of one of Rothko's last paintings is saturated with red acrylic paint; only scattered flecks of the white ground prevent the two rectangles from merging at the center. As with the black and blue painting, the red canvas is related to the vibrant late works on paper. Residue of masking tape adhesive is visible under the paint at the edges and appears to indicate that Rothko originally intended to frame the painting with a white border, but the tape was removed before he brushed a coat of red-stained acrylic gesso on the canvas.

During his last year Rothko investigated a variety of alternatives for his art, from the brown and grays to the black and aquamarine work on paper described by Malamud. Although he had recovered sufficiently from his illness to work on a moderately large scale in 1969, the majority of his production from the summer of 1968 to his death in

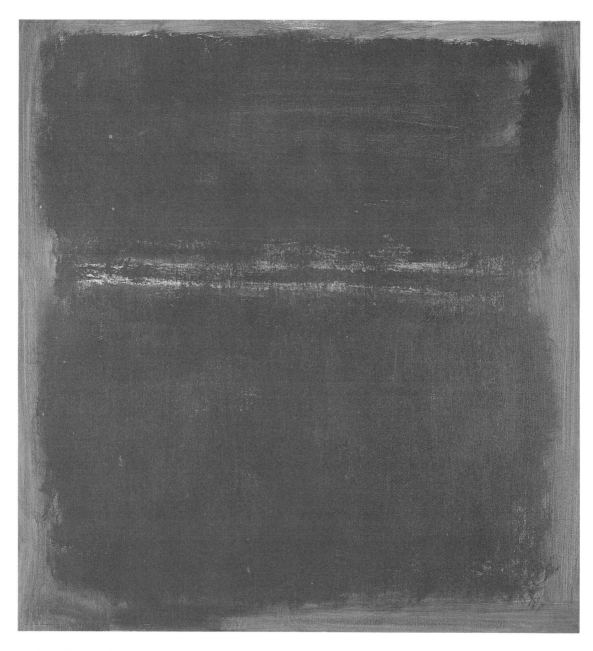

Mark Rothko. Untitled, 1970
Acrylic on canvas
60¼ x 57⅛ in.
(X5.70)

February 1970 was on paper. The shift in emphasis from canvas to paper was part of his artistic probing. He may have been following the advice of the early-twentieth-century art educator Franz Cizek, which he had copied many years earlier and frequently repeated to his own students. In his notes Rothko recorded that "Cizek advises those to whom a certain medium becomes too easy and who run the risk of becoming too skilled in that medium, to try another which presents more difficulties to them."[66] For the first time

since 1946 he concentrated his efforts toward the production of works on paper. And, just as during his Surrealist period, the emphasis on working on paper helped Rothko to discover new imagery and techniques. Early in his career he had pondered whether "means create styles or whether the style creates the invention of means." At the time he concluded that "Both [are] probably accurate."[67] Perhaps he still agreed with this statement in the last year of his life.

Of the late works, only the brown and gray papers and black and gray canvases have been subjects of art historical evaluation.[68] The absence of critical examinations of the other works of 1969 is not the result of negligent scholarship. In February 1969, shortly after their execution, most of the colorful papers from late 1968 and early 1969 were sold by Rothko to Marlborough Gallery, and only a handful of these works and those painted after the sale, remained in the artist's possession. Marlborough Gallery showed their works on paper at their Rome branch in February 1971 and the next month at Galleria Lorenzelli in Bergamo. Many of these works were sold to European collectors. The works that remained in Rothko's possession were not readily accessible until the recent consolidation and cataloguing of its collection by the Mark Rothko Foundation. Although scholars knew that Rothko's works of 1969 were not exclusively brown and gray and black and gray, without exact knowledge of the extent of the diversification of his last year, they concentrated on the available works, which led to somewhat distorted analyses of Rothko's last paintings.

Robert Goldwater was the first scholar to write about Rothko's black paintings and his article served as the source for subsequent studies. "In their somber colors," wrote Goldwater, "or lack of color, in their starkness and quiet, above all in a remoteness of a kind never evident in any of his previous work, they seem already to contain the mood that led to his tragic end."[69] Thomas Hess offered a different view of the last paintings in his review of the Biennale Internazionale d'Arte di Venezia in 1970. Hess considered Rothko's black paintings as part of a new beginning for the artist. According to Hess, "The *Black and Grey* paintings seem very much a part of Rothko's sensibility: the elegance (in a mathematician's sense of the word) with which the paint is applied, the extreme sensitivity of the 'horizon' where black and grey meet, the particular gleam in the white edge — a kind of dancing light." Hess continued:

> I am reminded of Barnett Newman's remark that when an artist gives up colors and moves into black and white, he is clearing the decks for something new, freeing himself for fresh experiment. Rothko's paintings have this nascent excitement.
> And at that point his life ended.
> He was hard at work painting until the day of his death. He had started on a new voyage.[70]

Hess's interpretation seems to have had little appeal and gained few disciples. Although scholars recognized the brown and grays and black and grays as part of the artist's sensibility, many succumbed to the romantic interpretation that these paintings were the

production of a depressed artist which contained premonitions of his suicide. Because Rothko, who was impressed by an article Goldwater had written on his work in 1961, sanctioned the choice of this noted art historian as the author of his biography, scholars assumed that Goldwater's details were informed and accurate. Although in general a sensitive portrayal of Rothko's last works, Goldwater's essay contains no mention of the fact that during 1969 Rothko produced large colorful papers; and although he did note that Rothko painted two colorful canvases late in his life, he felt that Rothko was fixed upon the dark works. Rothko himself may have contributed to Goldwater's interpretation by editing what he told his intended biographer and by his reluctance to explain his work. Goldwater himself admitted that "In his comments, fragmentary, brief, punctuated with long and heavy silences, and in his questions, freighted with a suppressed intensity, meanings were never mentioned."[71]

Rothko undoubtedly suffered from melancholia during the last year of his life. For several months after his illness he was incapacitated and unable to raise his arm, which prevented him from painting large works. Clearly, his aneurysm made him aware of his mortality; during the period following his illness he made an inventory of his collection, established the foundation bearing his name, and drew up a new will. His depression was further aggravated by his dependence on alcohol. In January of 1969, after a period of domestic turmoil, he separated from his wife and moved into his studio. His personal life a shambles, Rothko also worried about his public reputation. The overnight success of many younger artists disturbed him. He had struggled many years for recognition and in 1969 he felt neglected by a fickle public. For the first time since the mid-1930s he felt his position at the vanguard threatened.

Additional pressure came from a fear of artistic atrophy. As a man of his time, Rothko appears to have adopted the early-twentieth-century positivist attitude. In 1949 he insisted that "the progression of a painter's work . . . will be toward clarity, toward the elimination of all obstacles."[72] By the 1960s he had reduced his art to a minimum of form and color in order to achieve this clarity. And, although toward the end of his life he at times felt the restraints of the self-imposed limitations, the will to progress may have prevented him from deviating from his chosen course. Rothko was not unique in his need to remain at the front; he actually represented a general tendency. Such scholars as William Seitz noted the strain imposed on artists to keep up with the avant-garde. In 1963 he observed that,

> the dangers of constant pressure on artists to come up each season with something novel—to scrap the ideas of last year before they have been fully articulated or their depths plumbed—has [sic] not been sufficiently appreciated. The accelerating succession of publicized innovations has become both a joke and a serious problem. From both poles of the question, this group neurosis is a source of anxiety, frustration, and resentment.[73]

Commenting on the current art scene a few days before Rothko's death, Harold Rosenberg wrote in the *New Yorker*:

The artist today is offered a catalogue of styles and invited to choose. He knows, however, that the latest edition of the style book is already out of date. Everything that has been done in art opens another door, but the door faces a blank wall. To the artist, once someone else had made a move there is no use repeating it. In effect, therefore, each invention plugs up another avenue of advance. Thus having cancelled or submerged traditional modes in art, the new has reached the point of cancelling itself.[74]

During the sixties Rothko had witnessed the official death of Abstract Expressionism, the progression of art off the wall and into everyday life, and, in the work of the Minimalists, elimination of pictorial elements, a procedure he himself had pioneered. The internal and external pressures to progress probably contributed to his depression but may also have encouraged Rothko to experiment in his last years. The austerity of some of his later works, however, was not necessarily a reflection of his personal crises and it is likely that he would have denounced the psychological analysis of his work. In a lecture he delivered at Pratt Institute in 1958 he explained, "Painting a picture is not a form of self-expression. It is, like any other art, a language by which you communicate something about the world."[75] And he remarked to Katharine Kuh in an interview in the early sixties, "People talk about my work as personal—but I hope it's not about me."[76] When asked in the same interview whether his paintings reflected his moods and emotions of a particular period he declared, "Certainly not. If my later works are more tragic they are more comprehensive—not more personal."

To some extent all art emerges out of the experience of the artist in his time, and it is difficult to disassociate Rothko's works from his tragic life. However, the psychological approach trivializes the last works and contradicts the artist's aims. Also, the prevailing attitude that Rothko's black paintings reflect his emotional state does not account for the contemporaneous production of the dark works and the colorful paintings on paper and canvas, nor is it supported by his statements on art during the sixties. In his last works Rothko did not surrender to pure self-expression. Rather, he intended to invoke the tragic as he claimed to have done in previous works. Prompted by the great writers, musicians, artists, and philosophers, he always aspired to the heroic and the universal. Although he approached the content of his work with specific ideas in mind, he did not assign specific emotions to particular colors. In the appropriate context, any color could be tragic. Black dominated much of Rothko's work even during happier times and the grays of some of his late paintings on paper and canvas surely have their roots in the murky aquatic world of his own 1946 Surrealist watercolors. The brown and grays and black and grays with their minimal forms and restricted palette are part of Rothko's lifelong search for an elemental language. Along with the vibrant paintings on paper and canvas of the last year they constituted one more stage of exploration and experimentation. Yes, there is tragedy in these works, as there is tragedy in the times, and Rothko as shaman or dramatist translates for us his vision of the human dilemma. The fact that the brooding majesty of the late works has elicited a sense of tragedy from viewers is perhaps proof that Rothko did achieve his goal: the evocation of "basic human emotions—tragedy, ecstasy, doom."

NOTES

1. Max Weber, *Essays on Art* (New York, 1916), p. 26.

2. Ibid., p. 58.

3. Ibid., p. 74.

4. Eulogy for Milton Avery, delivered January 7, 1965, New York Society for Ethical Culture; transcript published in the exhibition catalogue Washington, D.C., National Collection of Fine Arts, Smithsonian Institution, *Milton Avery*, December 12, 1969-January 25, 1970.

5. Catherine Jones, "Noted One-Man Show Artist One-Time Portland Resident," *Sunday Oregonian,* July 30, 1933.

6. Ibid.

7. Transcript of interview with Adolph Gottlieb conducted by Dorothy Seckler, October 25, 1967; on file at the Adolph and Esther Gottlieb Foundation, New York.

8. Unpublished notebook of the late 1930s in the collection of the George C. Carson family; on extended loan to the Mark Rothko Foundation, New York.

9. Wilhelm Viola, *Child Art and Franz Cizek* (Vienna: Austrian Red Cross, 1936).

10. Ibid., p. 13.

11. Ibid., p. 24.

12. Ibid., p. 28.

13. The chronology of most of Rothko's works is problematic. Rothko usually dated works only when they were exhibited or sold. The large number of works which remained in his possession were not dated until 1968-69, when he inventoried his collection. At the time of the inventory Rothko dated his works from memory, and during this massive systematization he designated 1938 as the year in which he painted *Antigone*. Adolph Gottlieb, who kept careful records of his works, painted his first pictographs in 1941. It is unlikely that Rothko produced his mythic paintings three years before his colleague. Rothko's first wife, Edith Sachar Carson, recalled in a letter dated January 5, 1978, to Diane Waldman of the Solomon R. Guggenheim Museum, that it was in the early forties that his work changed dramatically; excerpt of letter in Diane Waldman, *Mark Rothko 1903-1970: A Retrospective* (New York, 1978), p. 34. Between 1938 and 1941 Rothko only exhibited his expressionistic figurative paintings.

Antigone was exhibited for the first time in the 1942 exhibition at R. H. Macy department store organized by Samuel Kootz. Rothko's *Omen of the Eagle* is the only mythic painting that can be dated with some certainty. The painting was reproduced in Sidney Janis, *Abstract and Surrealist Art in America* (New York, 1944), p. 118, with a 1942 date, and it was first shown in February 1943 in *The New York Artists Painters* exhibition. Although 1942 is written on the back of *The Omen of the Eagle*, Rothko's inventory date of the late 1960s, which also appears on the reverse of the canvas, is 1940. The discrepancy between the inventory date and the date published and inscribed on the reverse of the canvas seems to discredit the 1968-69 inventory dates of the mythic paintings. See Waldman, op. cit., pp. 26, 38; Mary Davis MacNaughten in *Adolph Gottlieb: A Retrospective* (New York: The Arts Publisher in association with the Adolph and Esther Gottlieb Foundation, 1981), p. 51, n. 39; Irving Sandler in *Mark Rothko Paintings 1948-69* (New York: Pace Gallery, 1983), p. 13, n. 10.

14. Transcript of interview with Adolph Gottlieb conducted by Martin Friedman, August 1962; on file at the Adolph and Esther Gottlieb Foundation, New York.

15. Quoted in Janis, op. cit., p. 118.

16. "The Portrait and the Modern Artist," broadcast with Adolph Gottlieb, *Art in New York*, WNYC, October 13, 1943; transcript published in *Adolph Gottlieb: A Retrospective*, op. cit., "Appendix B," p. 170.

17. Letter by Mark Rothko and Adolph Gottlieb, with the unacknowledged collaboration of Barnett Newman, in Edward Alden Jewell, "The Realm of Art: A New Platform and Other Matters: 'Globalism' Pops into View," *New York Times,* June 13, 1943.

18. Friedrich Nietzsche, *The Birth of Tragedy*, Walter Kaufmann, trans. (New York, 1967), p. 73. For discussion of Nietzsche's influence on Rothko, see Stephen Polcari, "The Intellectual Roots of Abstract Expressionism: Mark Rothko," *Arts*, 54, no. 1 (September 1979), pp. 124-34; Dore Ashton, *About Rothko* (New York, 1983), pp. 50-57, 66, 78, 79, 118-20.

19. Nietzsche, op. cit., p. 73.

20. Letter of 1943 in the collection of the George C. Carson family; on extended loan to the Mark Rothko Foundation, New York.

21. "Personal Statement," in the exhibition catalogue Washington, D.C., David Porter Gallery, *A Painting Prophecy—1950*, February, 1945, n.p.

22. Quoted in Dore Ashton, "Art: Lecture by Rothko," *New York Times*, October 31, 1958, p. 26.

23. "The Romantics Were Prompted," *Possibilities I* (Winter 1947/8), p. 84.

24. Lee Seldes, *The Legacy of Mark Rothko* (New York, 1978), p. 19.

25. Ben Wolf, "Mark Rothko Watercolors," *Art Digest*, 20, no. 15 (May 1, 1946), p. 1.

26. "Reviews and Previews," *Art News*, 45, no. 2 (April 1946), p. 55.

27. Letter to Laurine Collins, May 21, 1947; on file at the Brooklyn Museum.

28. Interview with Ernest Briggs conducted by Barbara Shikler, July 12 and October 21, 1982; transcript on file at the Archives of American Art, Smithsonian Institution, Washington, D.C.

29. Belle Krasne, "Mark of Rothko," *Art Digest*, 24, no. 8 (January 15, 1950), p. 17.

30. "One-Picture Wall or Many-Picture Wall," *Vogue* (April 1950), p. 66.

31. Quoted in "A Symposium on How to Combine Architecture, Painting and Sculpture," *Interiors*, 110, no. 10 (May 1951), p. 108.

32. Clement Greenberg, "'American-Type' Painting," *Partisan Review*, 22 (Spring 1955), pp. 193-94; reprinted and revised in Greenberg, *Art and Culture: Critical Essays* (Boston, 1961), pp. 225-27.

33. Lawrence Alloway, "The American Sublime," *Living Arts*, 2 (1963), p. 14; reprinted in Alloway, *Topics in American Art since 1945* (New York, 1975), p. 34.

34. John Canaday, "Is Less More, and When for Whom? Rothko Show Raises Questions about Painters, Critics and Audience," *New York Times*, January 22, 1961.

35. Robert Goldwater, "Reflections on the Rothko Exhibition," *Arts*, 35, no. 6 (March 1961), p. 45.

36. Unpublished notebook, collection of the George C. Carson family, op. cit.

37. Robert Goldwater, "Rothko's Black Paintings," *Art in America*, 59, no. 2 (March-April 1971), p. 58.

38. Interview with Katharine Kuh, c. 1961; on file in Katharine Kuh papers, Archives of American Art, Smithsonian Institution, Washington, D.C.

39. Quoted by Dore Ashton in her personal unpublished notes of a lecture delivered by Rothko at Pratt Institute, October 27, 1958.

40. Nietzsche, op. cit., 64.

41. Quoted in Selden Rodman, *Conversations with Artists* (New York, 1957), pp. 93-94.

42. Nietzsche, op. cit., p. 37.

43. Brian O'Doherty, *American Masters: The Voice and the Myth* (New York, 1973), p. 153. Rothko, however, most likely had Mozart's music in mind rather than Beethoven's.

44. Nietzsche, op. cit., p. 66.

45. "The Portrait and the Modern Artist," op. cit.

46. New York, Art of This Century, *Mark Rothko Paintings*, January 9-February 4, 1945.

47. "The Romantics Were Prompted," op. cit., p. 84.

48. William C. Seitz, "Abstract-Expressionist Painting in America: An Interpretation Based on the Work and Thought of Six Key Figures," Ph.D. diss., Princeton University, 1955, pp. 274-75; Cambridge, Mass., 1983, p. 102.

49. Thomas Hess, "Reviews and Previews," *Art News*, 54, no. 4 (Summer 1955), p. 54.

50. "Statement on His Attitude in Painting," *The Tiger's Eye*, 1, no. 9 (October 1949), p. 114.

51. Rodman, op. cit., pp. 93-94.

52. Dore Ashton, "Art," *Arts and Architecture*, 75, no. 4 (April 1958), p. 8.

53. Interview with Katharine Kuh, op. cit.

54. Recent conservation analysis by the Mark Rothko Foundation's conservator, Dana Cranmer, has revealed that Rothko began to experiment with acrylic and Magna paint on his canvases as early as 1947. However, he usually combined these with oil paint, tempera, and rabbit-skin glue with powdered pigments.

55. Ida Kohlmeyer, "About Rothko," *Arts Quarterly*, 4, no. 4 (October/November/December 1982), p. 59.

56. Rothko usually signed and dated the backs of Krushenick's and Goldreyer's mounts. The works on paper mounted on canvas or linen tended to pucker. Hence, after Rothko's death, the conservator for Marlborough Gallery, New York, Alan Thielker, developed a new design for mounting the works on paper. In Thielker's method the paper was mounted on Masonite honeycomb panels approximately 1½ inches thick. Following the earlier examples of mounting, the sides of these mounts were also painted the color of the stained fields. The backs of the mounts were often painted a pale gray or grayish-brown and occasionally bear the impression of the Rothko estate stamp that Marlborough Gallery used.

57. Goldwater, "Rothko's Black Paintings," op. cit., p. 58.

58. For the history of the Seagram murals, see Ronald Alley, *Catalogue of The Tate Gallery's Collection of Modern Art: Other than Works by British Artists* (London,

1981), pp. 657-63; New York, Pace Gallery, *Rothko: The 1958-1959 Murals,* 1979.

59. John Fischer, "Mark Rothko: Portrait of the Artist as an Angry Man," *Harper's,* 241, no. 1442 (July 1970), p. 16.

60. Zurich, Kunsthaus, *Mark Rothko,* March 21-May 9, 1971, essay by Werner Haftmann, translated by Margery Scharer, p. viii.

61. Rothko's instructions for the installation of his retrospective at the Whitechapel Art Gallery, London, 1961. Instructions were typed and sent by the Museum of Modern Art, New York, and are on file at the Whitechapel Art Gallery.

62. Letter to John and Dominique de Menil, January 1, 1966, on file in the Menil Foundation, Houston; excerpt from letter in *The Rothko Chapel* (Houston, 1979), p. 4.

63. Dore Ashton, personal unpublished notes, February 26, 1969.

64. Conversation with the author, January 1982.

65. Bernard Malamud, "The Aquamarine Sunrise: A Memory of Rothko," in Waldman, op. cit., p. 15.

66. Rothko, unpublished notebook, collection of the George C. Carson family, op. cit.

67. Ibid.

68. For discussions of the black and gray canvases and brown and gray papers, see Goldwater, "Rothko's Black Paintings," op. cit.; Waldman, op. cit., pp. 68-69; Eliza Rathbone, "Mark Rothko: The Brown and Gray Paintings," in the exhibition catalogue Washington, D.C., National Gallery of Art, *American Art at Mid-Century: The Subjects of the Artist,* 1978, pp. 242-69; Polcari, op. cit., pp. 133-34; Ashton, *About Rothko*, op. cit., pp. 186-91.

69. Goldwater, "Rothko's Black Paintings," op. cit., p. 58.

70. Thomas B. Hess, "Rothko: A Venetian Souvenir," *Art News,* 69, no. 7 (November 1970), p. 74.

71. Goldwater, "Rothko's Black Paintings," op. cit., p. 62.

72. "Statement on His Attitude in Painting," op. cit., p. 114.

73. William C. Seitz, "The Rise and Dissolution of the Avant-Garde," *Vogue* (September 1, 1963), p. 232.

74. Harold Rosenberg, "Keeping Up," *New Yorker* (February 21, 1970), p. 82; reprinted in *The De-definition of Art* (New York, 1972), p. 223.

75. Quoted by Dore Ashton in personal unpublished notes of Rothko's lecture, op. cit.

76. Interview with Katharine Kuh, op. cit.

PLATES

1 (above) Untitled, late 1920s
Watercolor, ink, pencil on paper
20⅛ x 14³/₁₆ in. image
22⁵/₁₆ x 15⅛ in. sheet
(1063.25/27)

2 (facing page top) Untitled, late 1920s
Watercolor, ink on paper
14½ x 21 in. image
15½ x 22¹¹/₁₆ in. sheet
(1083.25/27)

3 (facing page bottom) Untitled, c. 1930
Tempera on paper
7¾ x 9¹³/₁₆ in. image
8 x 10 in. sheet
(N 30)

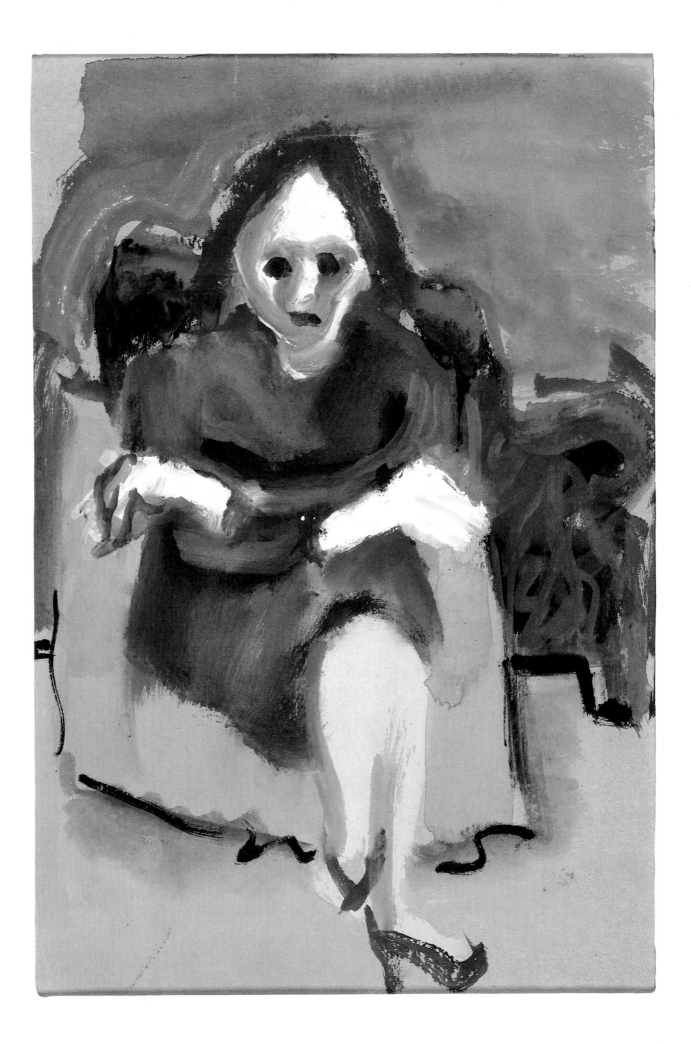

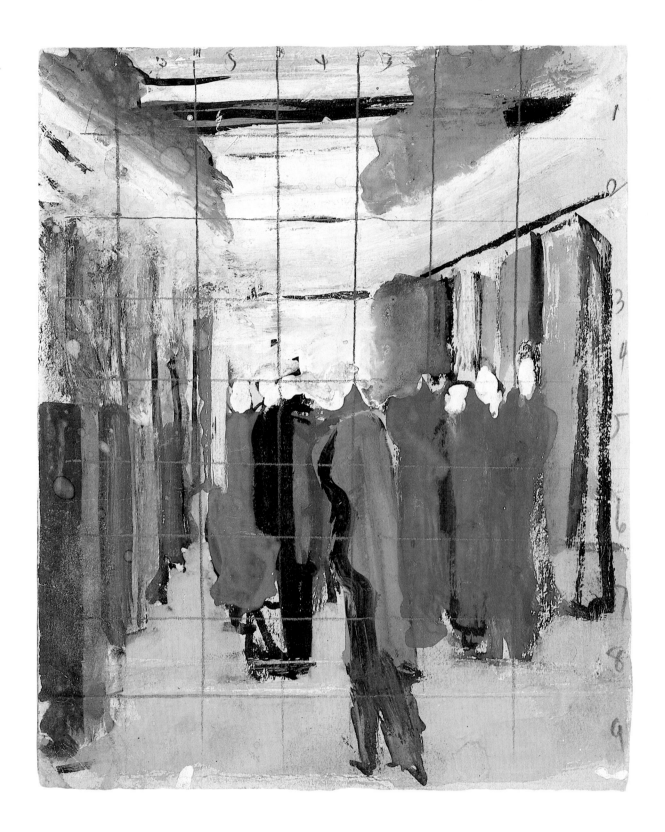

4 Untitled, 1930s
Tempera on colored construction paper
11⅜ x 7¾ in. image
12 x 8 in. sheet
(O 58)

5 Untitled, 1930s
Watercolor on paper
9 x 7½ in.
(O 55)

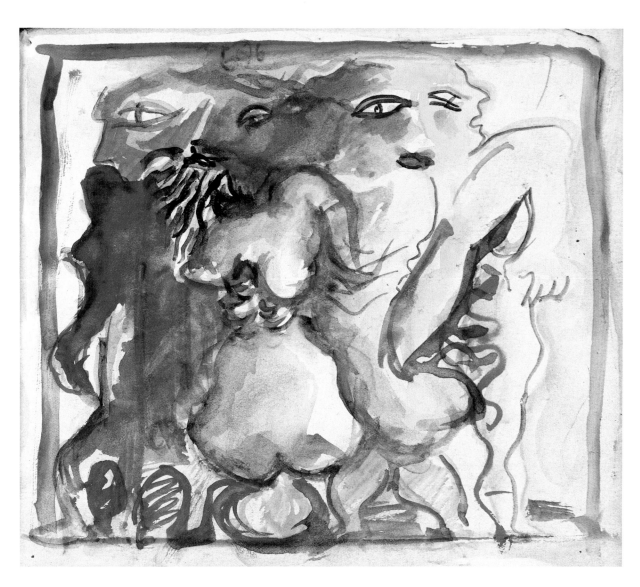

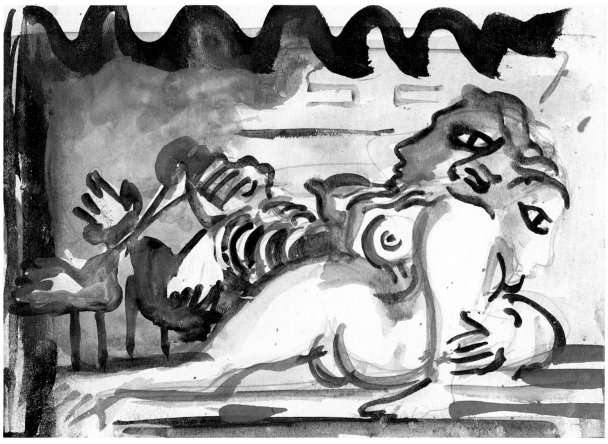

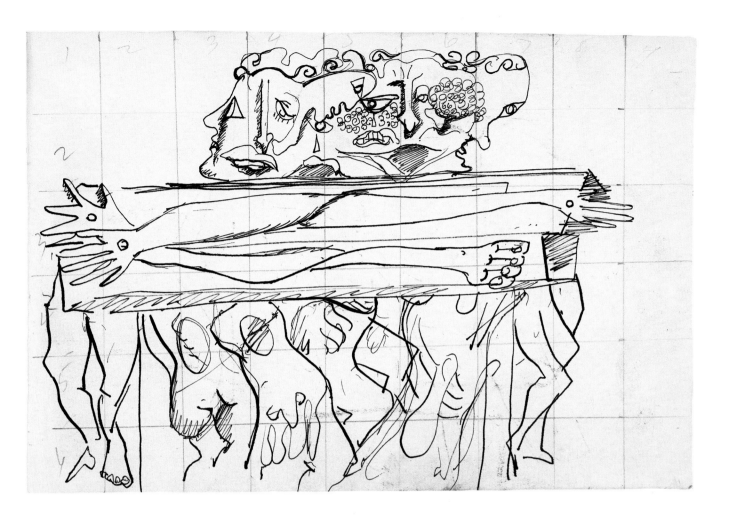

6 (facing page top) Untitled (study for *Antigone*), early 1940s
Watercolor on paper
5⅝ x 6⁹⁄₁₆ in. image (reproduced actual size)
6½ x 7 in. sheet
(N 5)

7 (facing page bottom) Untitled, early 1940s
Watercolor, pencil on paper
4½ x 6⁹⁄₁₆ in. image (reproduced actual size)
5¹⁄₁₆ x 6¹⁵⁄₁₆ in. sheet
(O 19F)

8 (above) Untitled, early 1940s
Pen and ink, pencil on paper
6 x 9 in.
(H6.4)

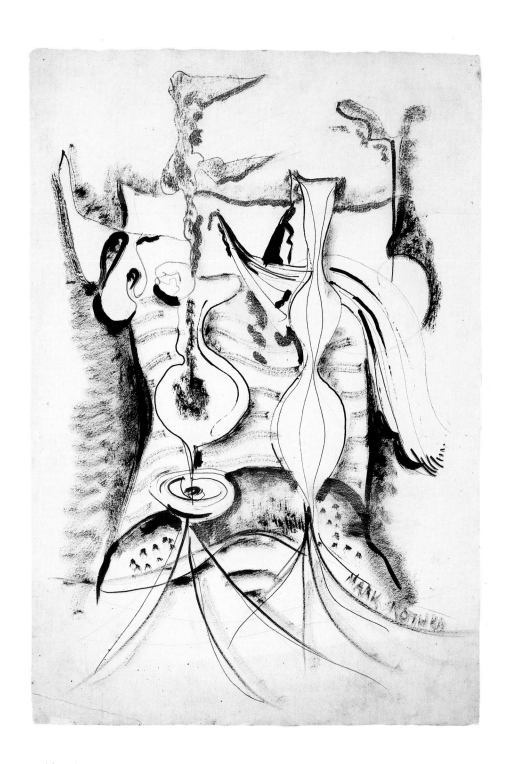

9 (above) Untitled, 1944-45
Ink and pencil on paper
22⅝ x 15½ in.
(1025.41)

10 (facing page top) Untitled, 1944-45
Ink on paper
14½ x 20¼ in. image
15 x 21¹/₁₆ in. sheet
(1038.41F)

11 (facing page bottom) Untitled, 1944-45
Ink on paper
14¾ x 22⅛ in. image
15⁹/₁₆ x 22⅝ in. sheet
(1039.41)

12 Untitled, 1944-45
Watercolor, tempera, ink, pencil on paper
21¹³/₁₆ x 27⅛ in.
(1128.40)

13 Untitled, 1944-45
Watercolor, ink, tempera on paper
21^{15}/$_{16}$ x 30^{1}/$_{16}$ in. image
22^{9}/$_{16}$ x 30^{15}/$_{16}$ in. sheet
(1099.44)

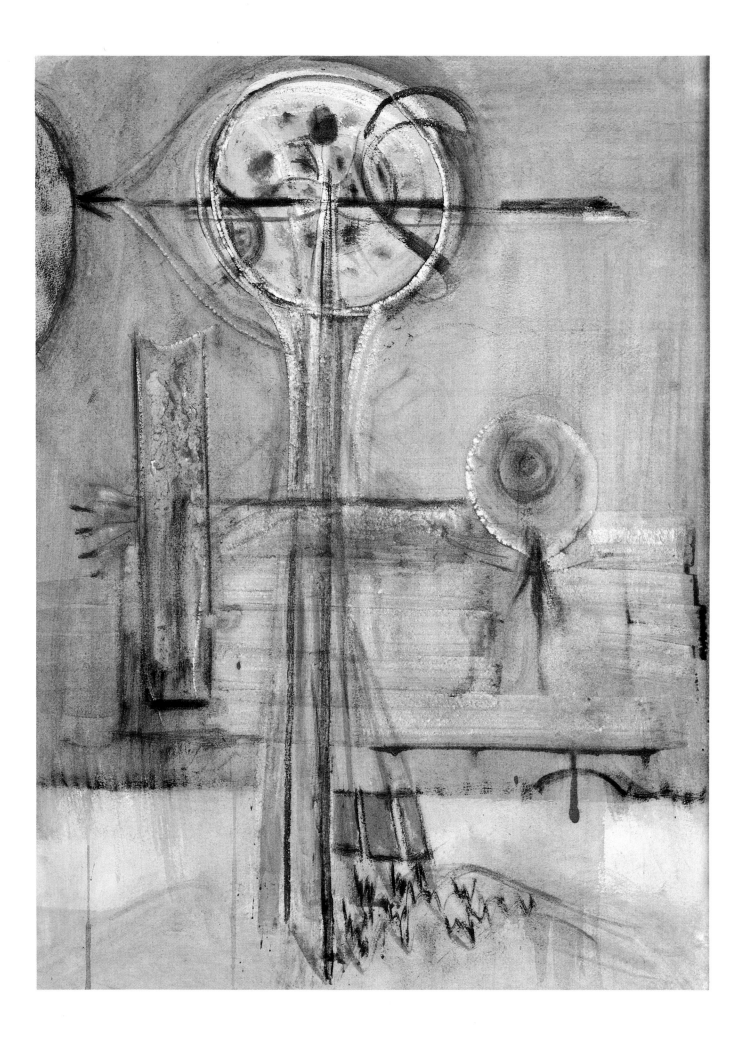

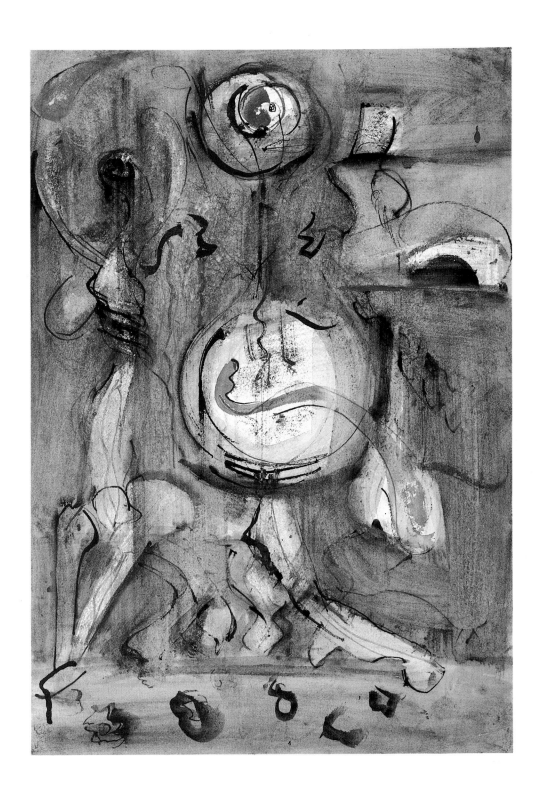

14 Untitled, 1945-46
Watercolor, ink on paper
26¹³/₁₆ x 19⁷/₈ in. image
27½ x 20½ in. sheet
(1130.40)

15 Untitled, 1945-46
Watercolor, ink, tempera, pencil on paper
20¹³/₁₆ x 14¹¹/₁₆ in. image
21¼ x 15¼ in. sheet
(1137.40)

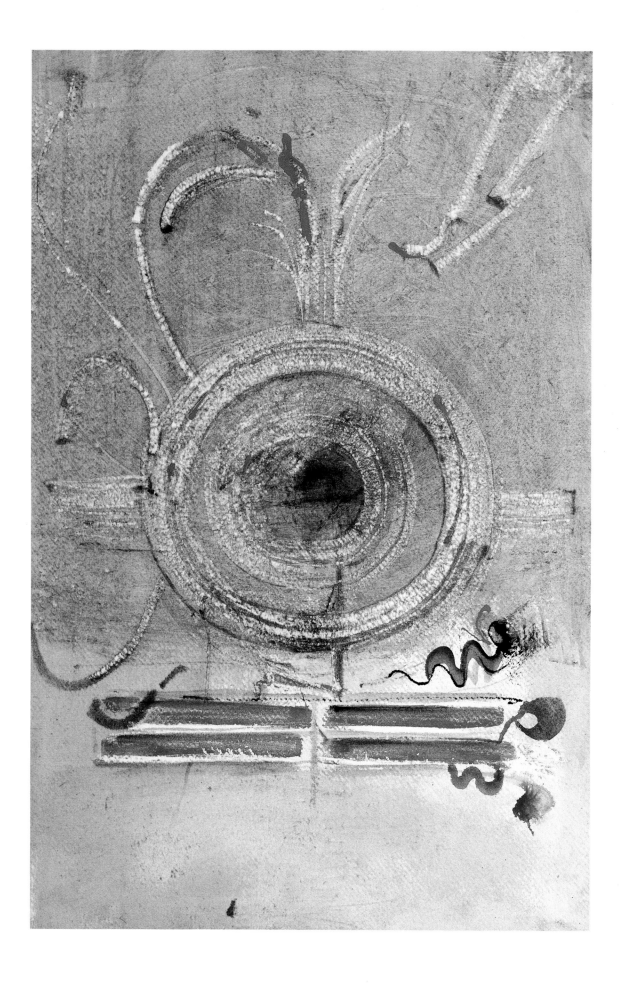

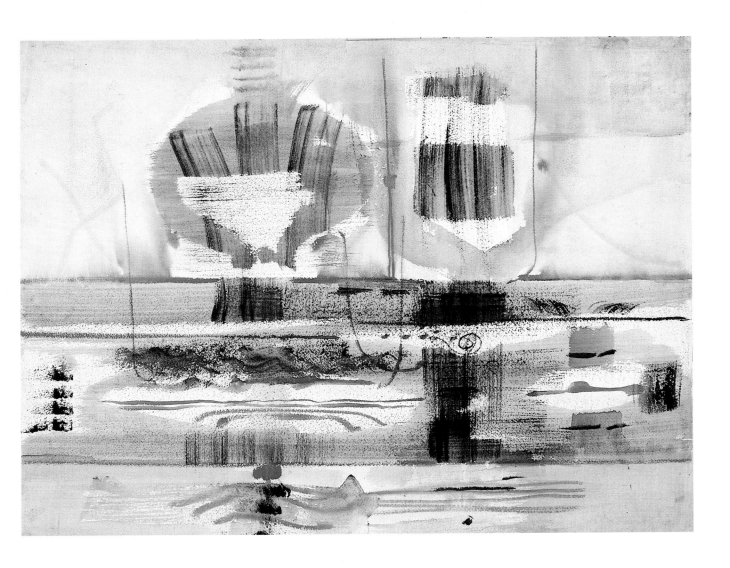

16 Untitled, 1945-46
Watercolor, pencil, ink on paper
21¾ x 14⁹⁄₁₆ in. image
22½ x 15⁷⁄₁₆ in. sheet
(1036.41F)

17 Untitled, 1945-46
Watercolor, ink on paper
22⅛ x 30¹³⁄₁₆ in. image
22¾ x 31⁵⁄₁₆ in. sheet
(1134.40)

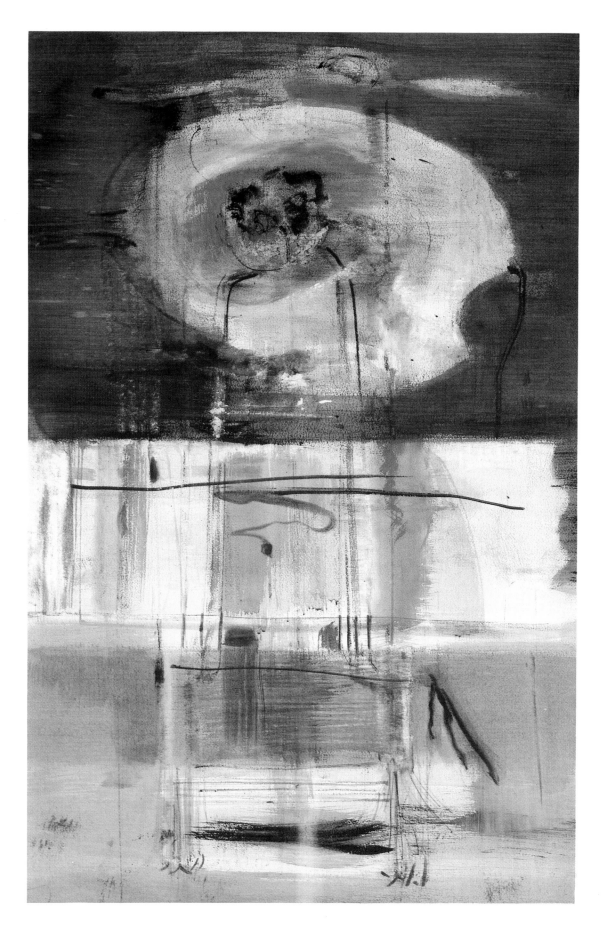

18 Untitled, 1945-46
Watercolor, ink on paper
39⅞ x 26⅜ in. image
40¹¹⁄₁₆ x 27¹⁄₁₆ in. sheet
(1007.45)

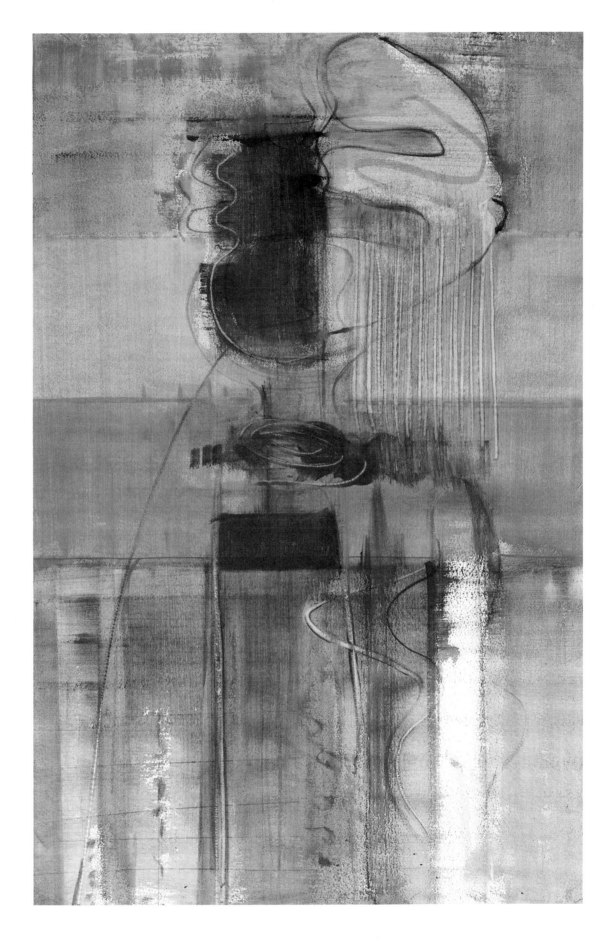

19 Untitled, 1945-46
Watercolor, ink on paper
40 x 26½ in. image
40⅝ x 27¹/₁₆ in. sheet
(1011.45)

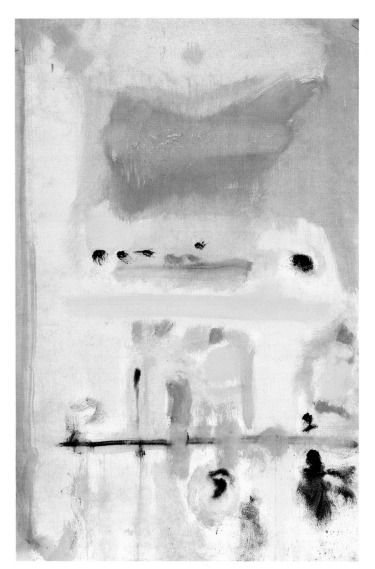

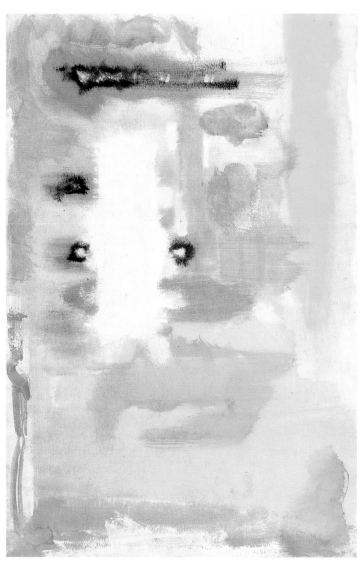

20 Untitled, 1949
Watercolor, tempera on paper
39⁵/₁₆ x 26⁵/₁₆ in. image
40¹/₈ x 27 in. sheet
(1241.49)

21 Untitled, 1949
Watercolor, tempera on paper
39⁷/₈ x 25⁷/₈ in. image
40¹/₁₆ x 26⁵/₈ in. sheet
(1243.49)

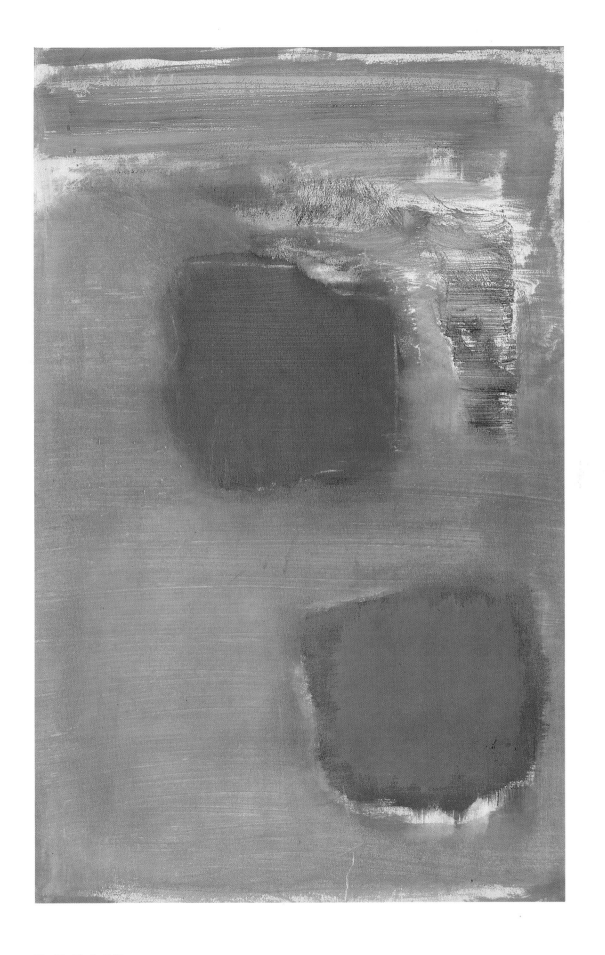

22 Untitled, 1949
Watercolor, tempera on paper
40³/₁₆ x 26¹/₁₆ in. image
41¹/₁₆ x 27¹/₄ in. sheet
(1242.49)

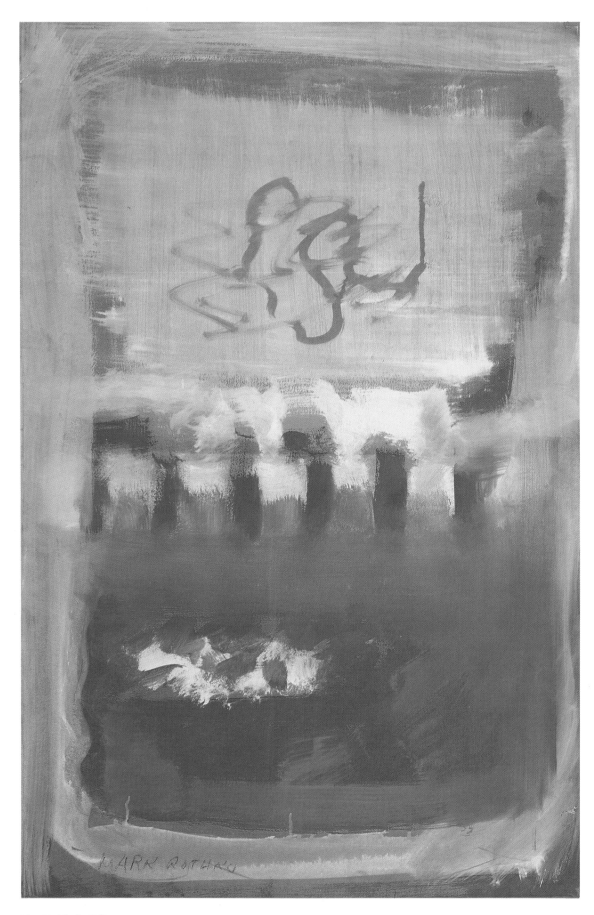

23 Untitled, 1949
Watercolor, tempera on paper
39¾ x 26⁵⁄₁₆ in. image
42⅜ x 28⅜ in. sheet
(1238.49)
Lent by Kate and Christopher Rothko

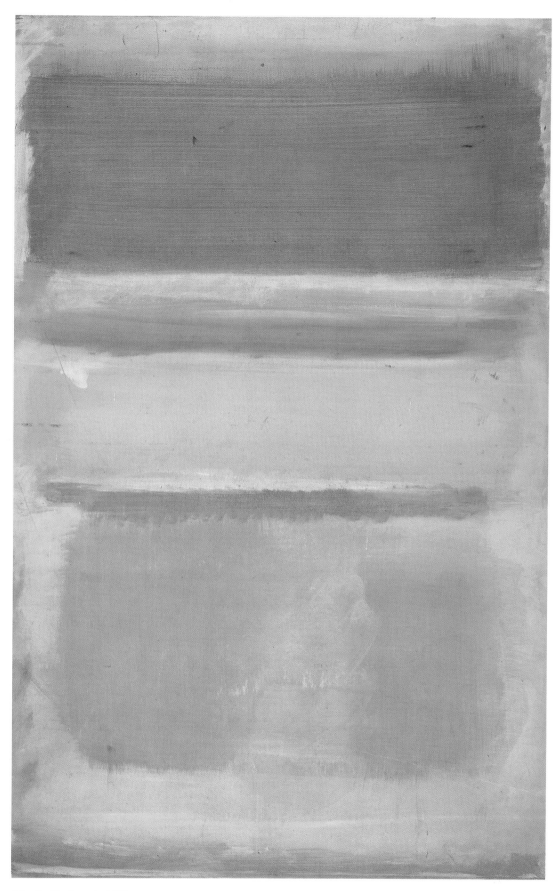

24 Untitled, early 1950s
Watercolor, tempera on paper
39⅜ x 26½ in. image
40⅞ x 27³⁄₁₆ in. sheet
(1240.52)
Lent by Kate and Christopher Rothko

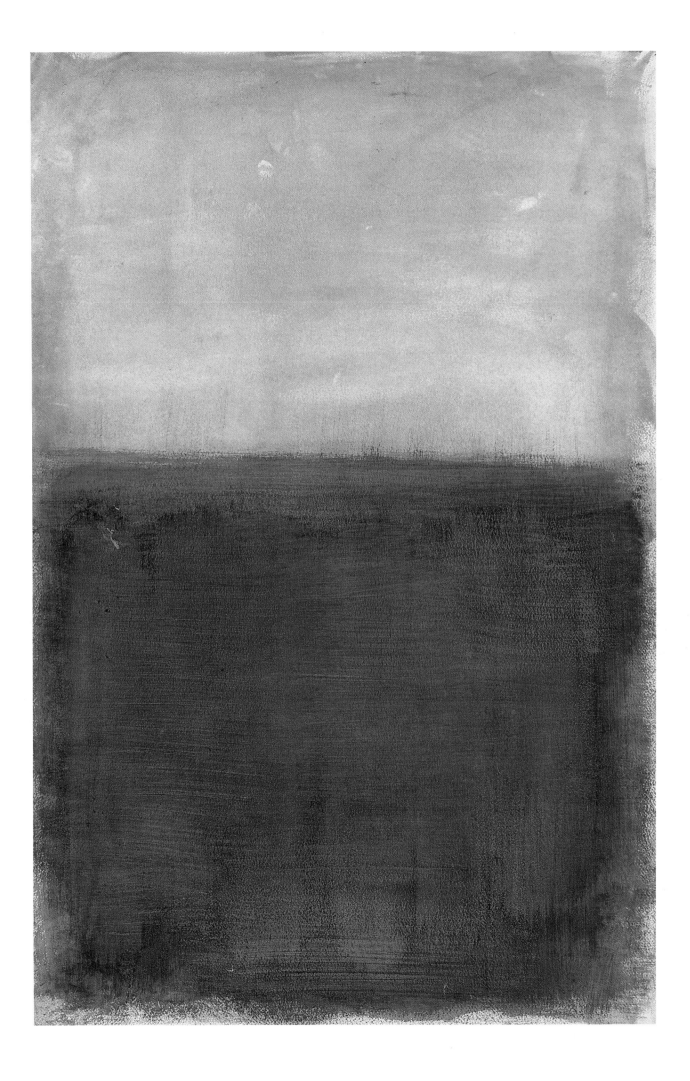

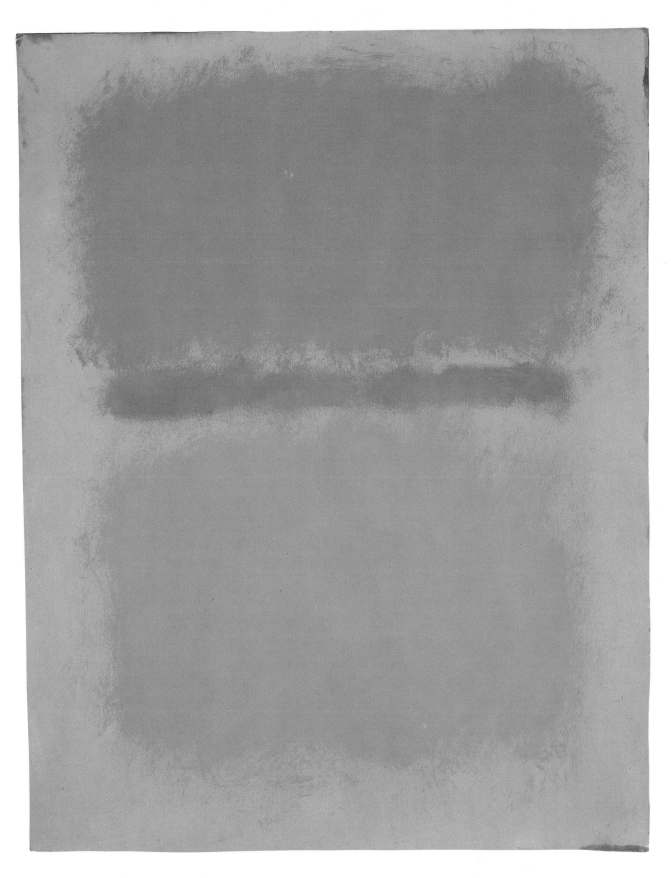

25 Untitled, early 1950s
Watercolor, tempera on paper
39⁹⁄₁₆ x 25¹³⁄₁₆ in. image
40½ x 27⅛ in. sheet
(1245.52)
Lent by Kate and Christopher Rothko

26 Untitled, 1959
Oil on paper mounted on Masonite
23⅞ x 18⅞ x ⅞ in.
Collection Mr. and Mrs. David A. Wingate, New York

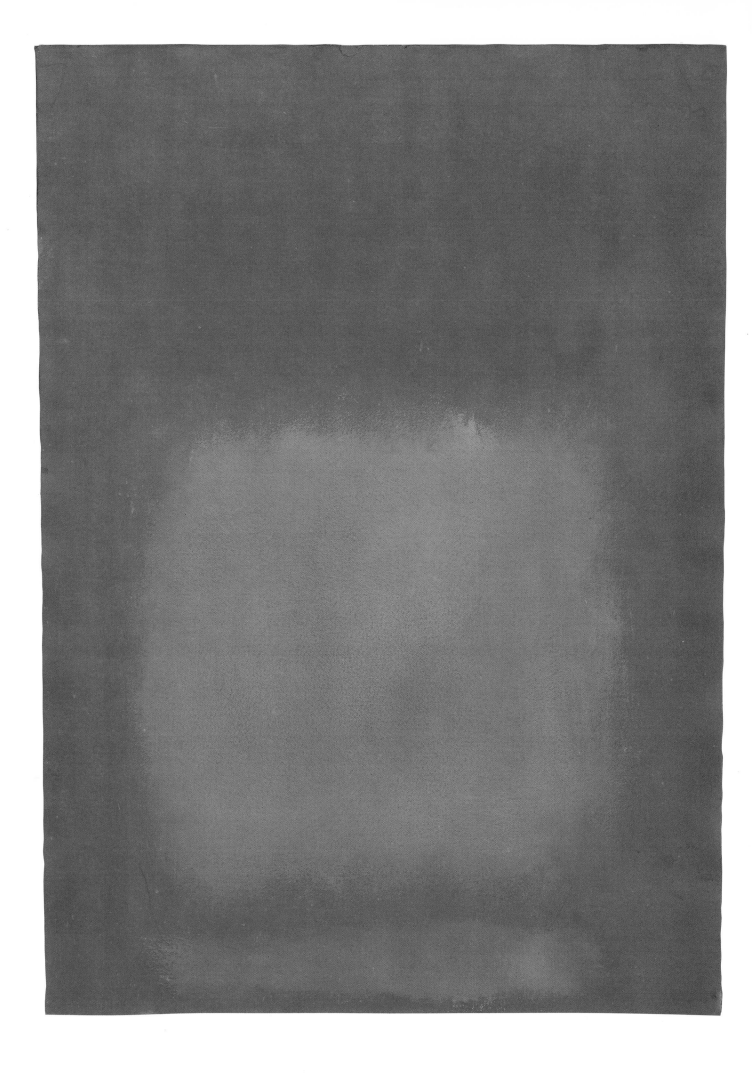

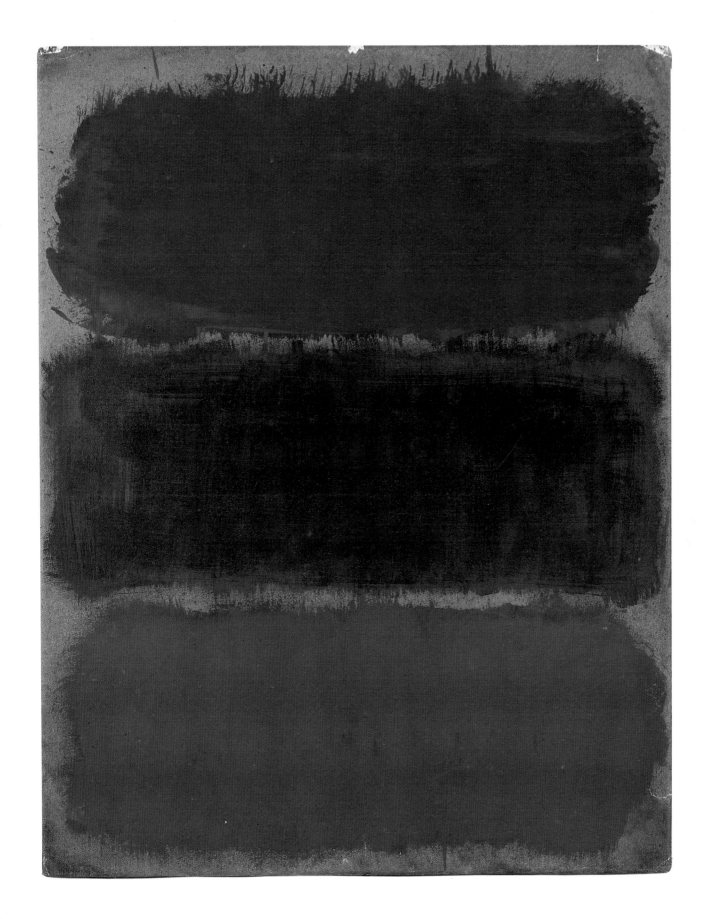

27 Untitled, c. 1959
Oil on paper mounted on linen
30½ x 21¹⁵/₁₆ x ¹³/₁₆ in.
Collection Mr. and Mrs. David A. Wingate, New York

28 Untitled, 1967
Acrylic on paper mounted on Masonite
23¹⁵/₁₆ x 18¹³/₁₆ x 1⁷/₁₆ in.
(1255.67)

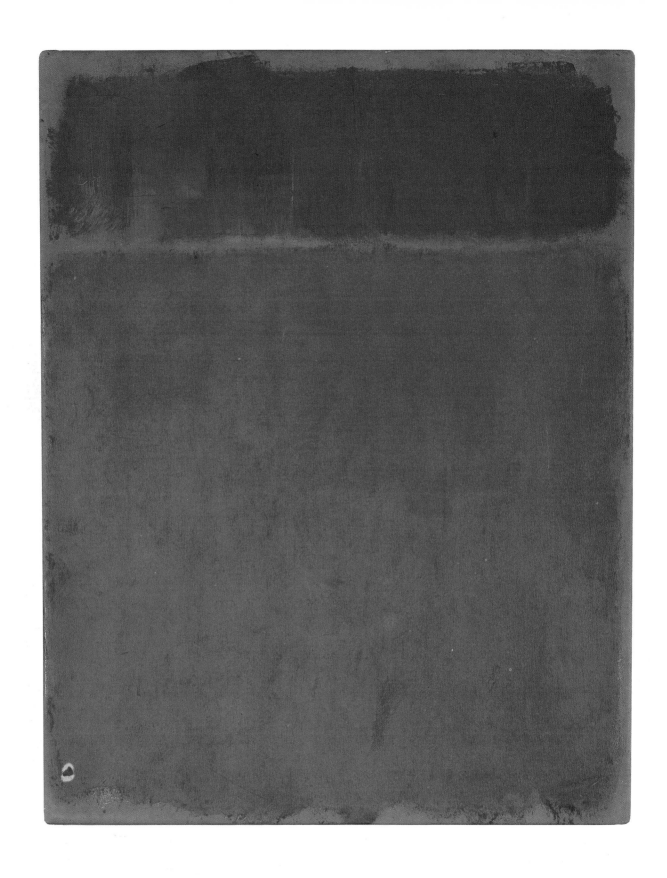

29 Untitled, 1967
Acrylic on paper mounted on Masonite
$23^{7}/_{8}$ x $18^{7}/_{8}$ x $1^{7}/_{16}$ in.
(1268.67)

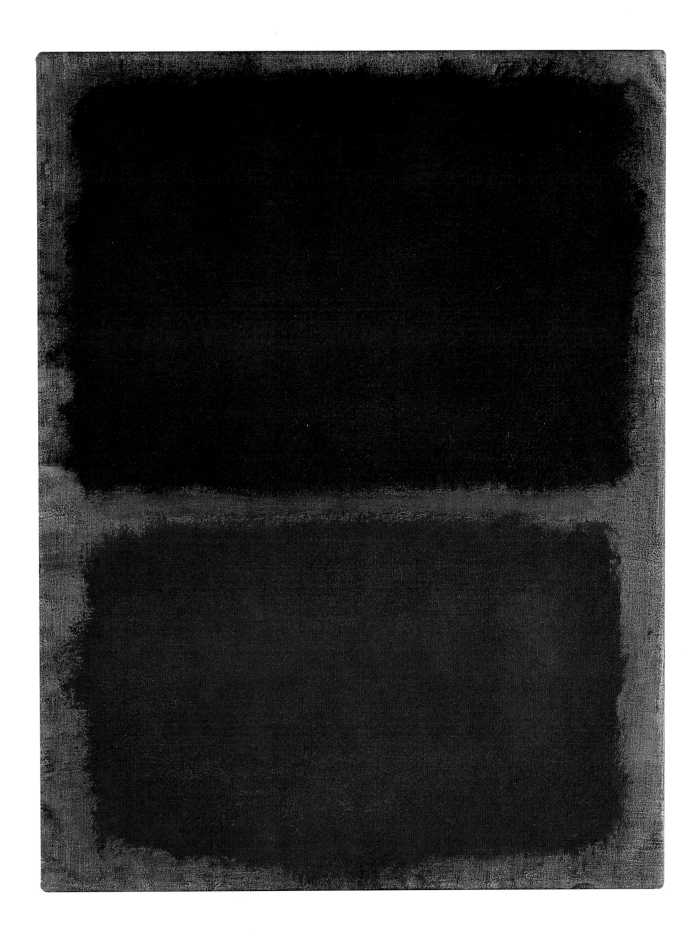

30 Untitled, 1967
Acrylic on paper mounted on Masonite
$25^9/_{16}$ x $19^{11}/_{16}$ x $1^7/_{16}$ in.
(1267.67)

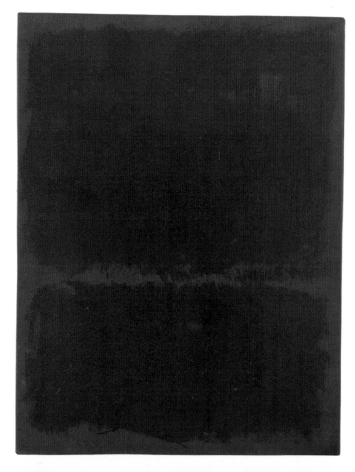

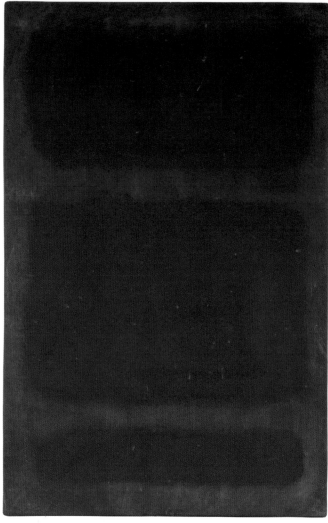

31 (top) Untitled, 1968
Acrylic on paper mounted on Masonite
32⅞ x 25⅜ x 1⁷⁄₁₆ in.
(1163.68)

32 (bottom) Untitled, 1968
Acrylic on paper mounted on Masonite
39⅝ x 26⅛ x 1⁷⁄₁₆ in.
(1183.68)

33 (facing page) Untitled, 1968
Acrylic on paper mounted on Masonite
34⅜ x 27¼ x 1⁷⁄₁₆ in.
(1185.68)

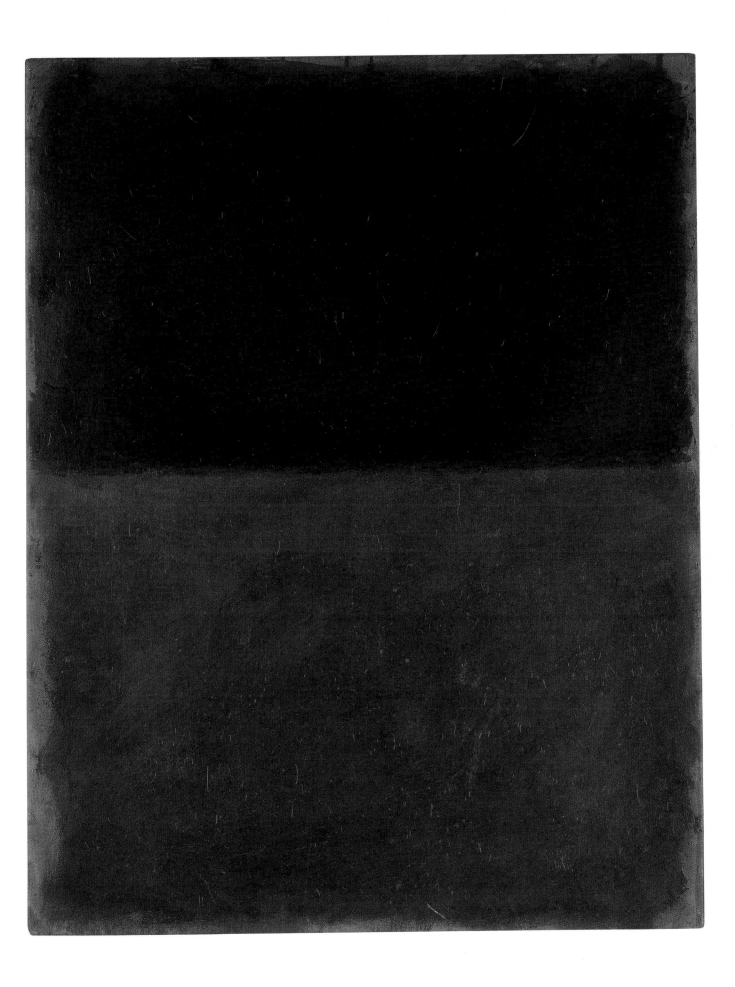

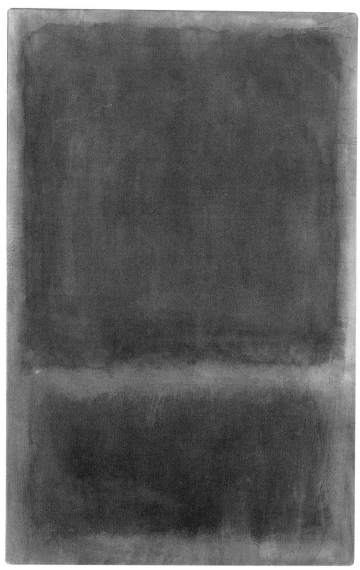

34 Untitled, 1968
Acrylic on paper mounted on Masonite
39¹/₈ x 25⁵/₈ x 1⁷/₁₆ in.
(1173.68)

35 Untitled, 1968
Acrylic on paper mounted on Masonite
40¹¹/₁₆ x 26³/₈ x 1⁷/₁₆ in.
(1184.68)

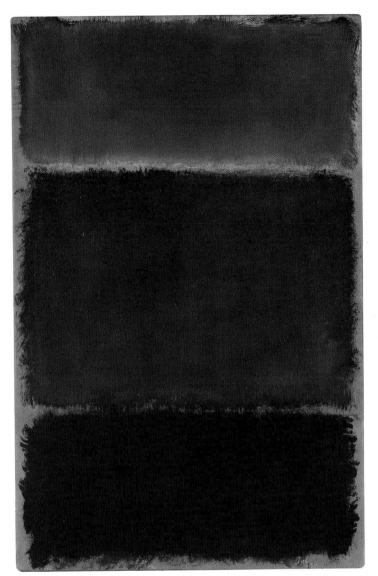

36 Untitled, 1968
Acrylic on paper mounted on Masonite
39¹¹/₁₆ x 25³/₄ x 1⁷/₁₆ in.
(1236.68)

37 Untitled, 1968
Acrylic on paper mounted on Masonite
39¹/₂ x 26³/₁₆ x 1⁷/₁₆ in.
(1162.68)

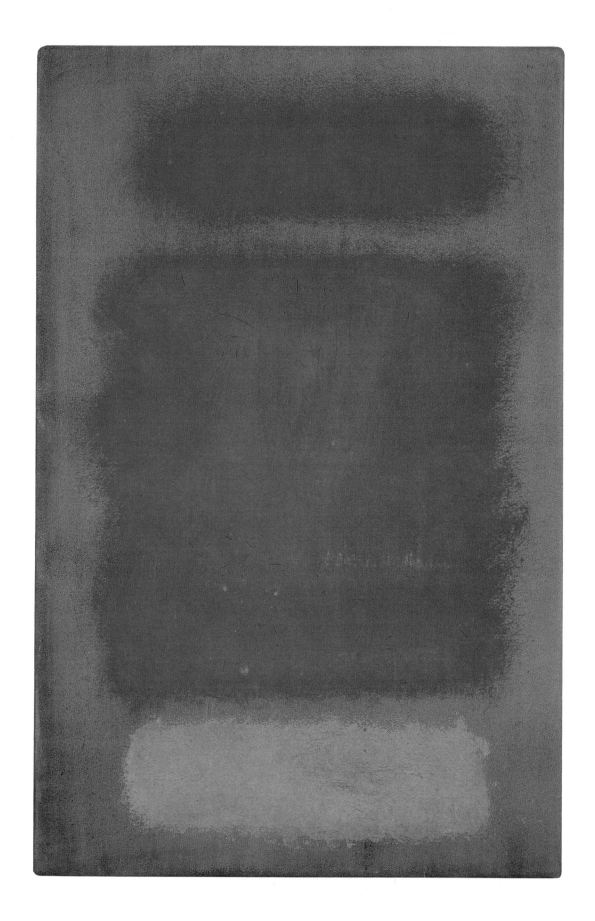

38　Untitled, 1968
Acrylic on paper mounted on Masonite
18¹/₁₆ x 11⁷/₈ x 1⁷/₁₆ in.
(1289.68)

39　Untitled, 1968
Acrylic on paper mounted on Masonite
24¹/₁₆ x 18¹/₄ x 1⁷/₁₆ in.
(1294.68)

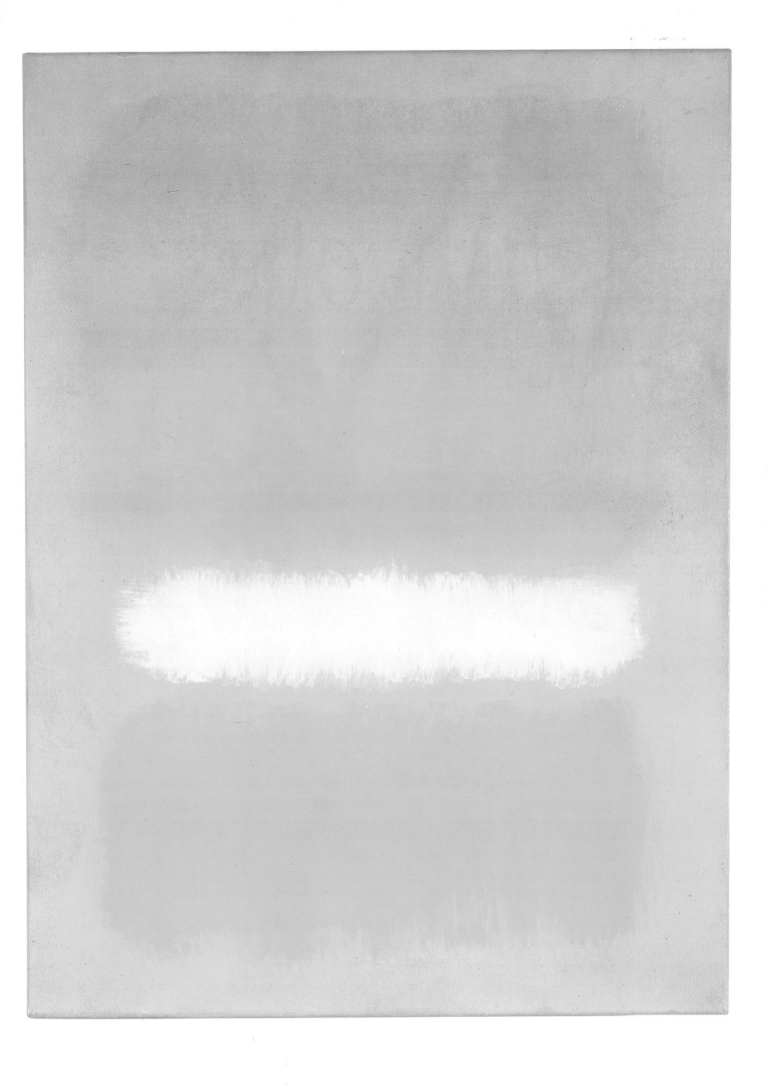

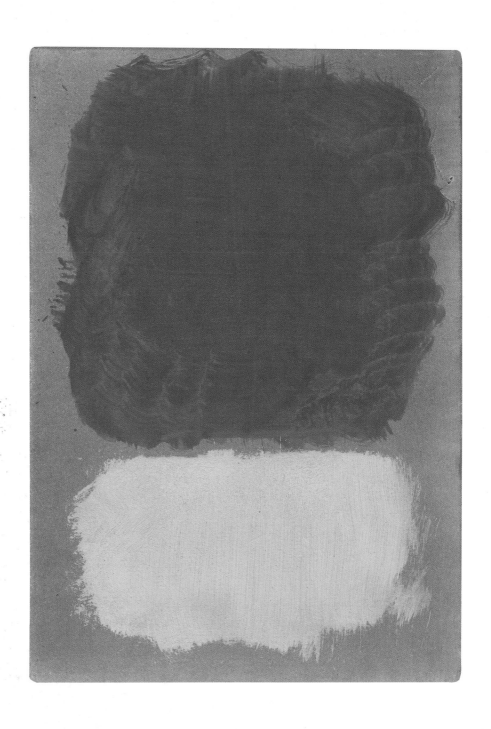

40 Untitled, 1968
Acrylic on paper mounted on Masonite
18$\frac{1}{16}$ x 12$\frac{3}{4}$ x 1$\frac{7}{16}$ in.
(1288.68)

41 Untitled, 1968
Acrylic on paper mounted on Masonite
24$\frac{1}{8}$ x 18$\frac{1}{8}$ x 1$\frac{7}{16}$ in.
(1286.68)

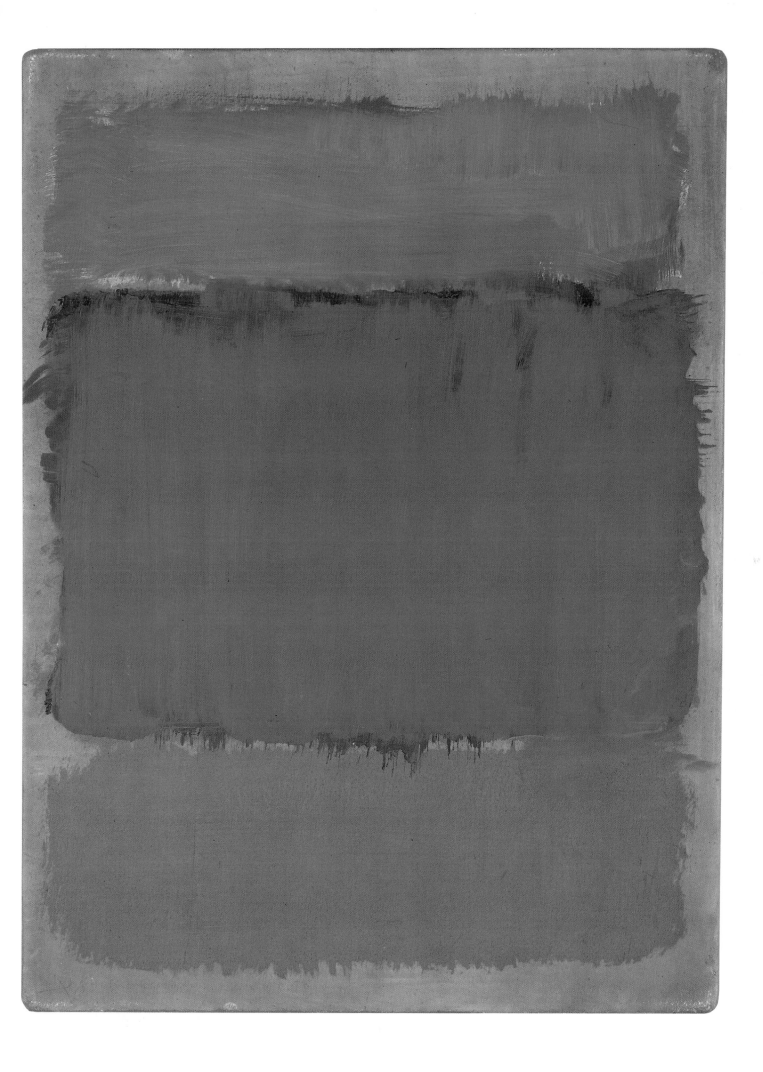

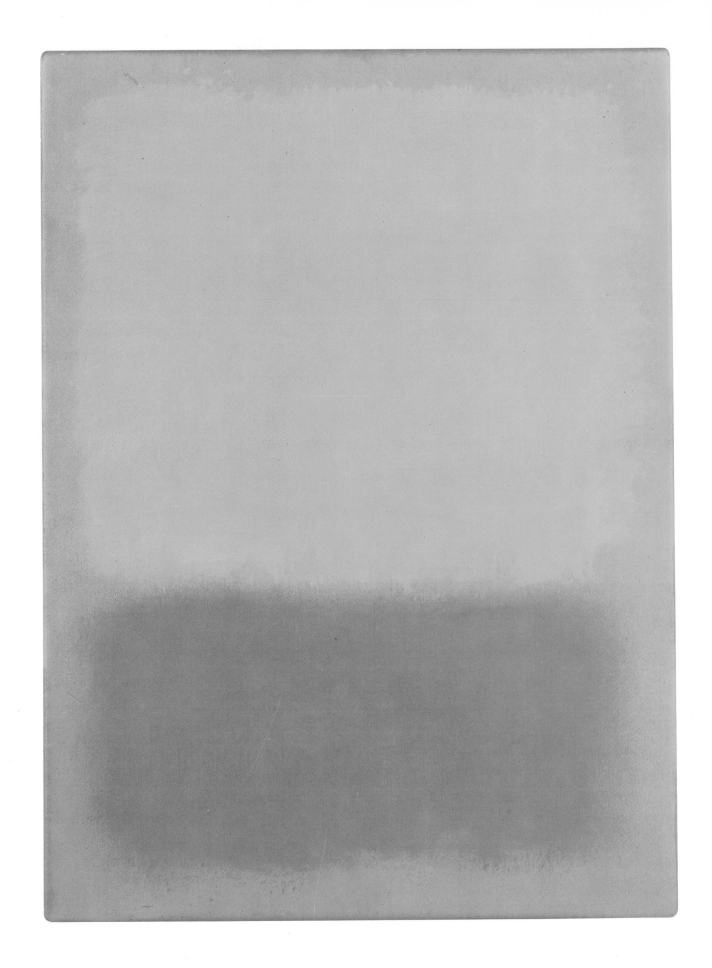

42 Untitled, 1968
Acrylic on paper mounted on Masonite
$24^{1}/_{16}$ x $18^{1}/_{16}$ x $1^{7}/_{16}$ in.
(1295.68)

47 Untitled (model for Tate Gallery installation), 1969
Tempera on colored construction paper
2½ x 6⅜ in. (reproduced actual size)
(H14.6)

48 Untitled (model for Tate Gallery installation), 1969
Tempera on colored construction paper
2½ x 6⅜ in. (reproduced actual size)
(H14.5)

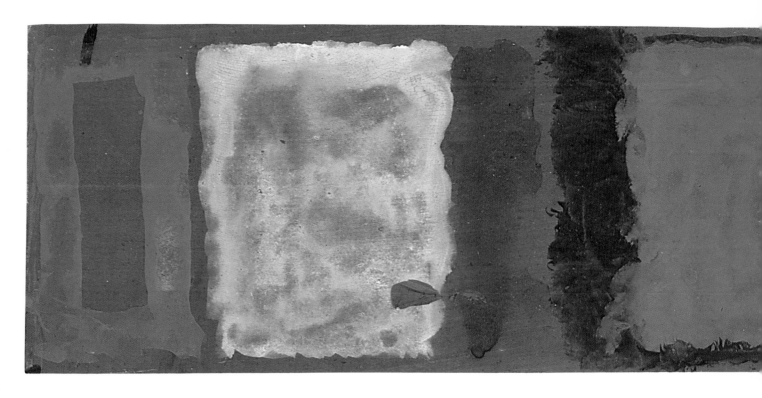

43 Untitled (sketch for Seagram murals), 1958-59
Crayon on colored construction paper
3¹¹/₁₆ x 18 in.
(H24.1)

44 *Mural Sketch 2* (sketch for Seagram murals), 1958-59
Tempera on paper
4¹/₂ x 16⁷/₈ in.
(H25.2)

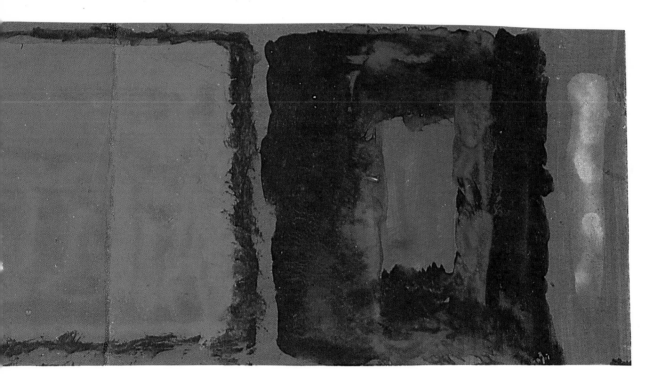

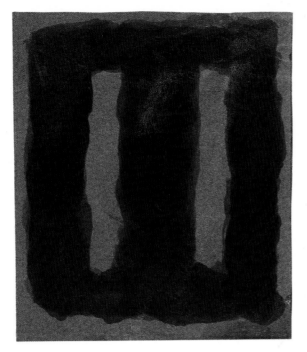

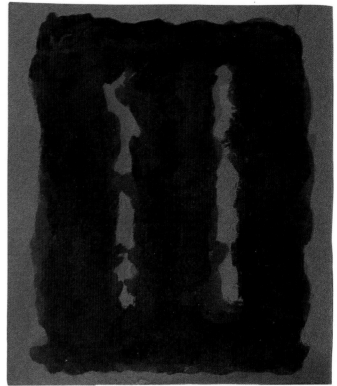

45 Untitled (model for Tate Gallery installation), 1969
Tempera on colored construction paper
3⅜ x 3 in. (reproduced actual size)
(H14.1)

46 Untitled (model for Tate Gallery installation), 1969
Tempera on colored construction paper
4 x 3⅜ in. (reproduced actual size)
(H14.2)

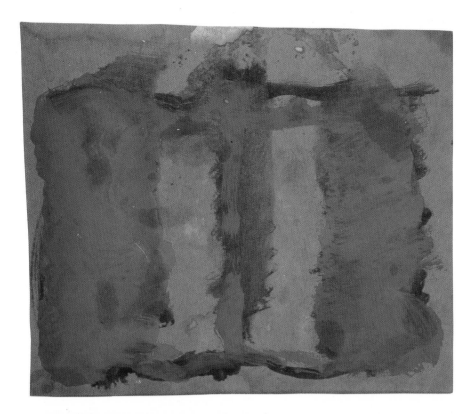

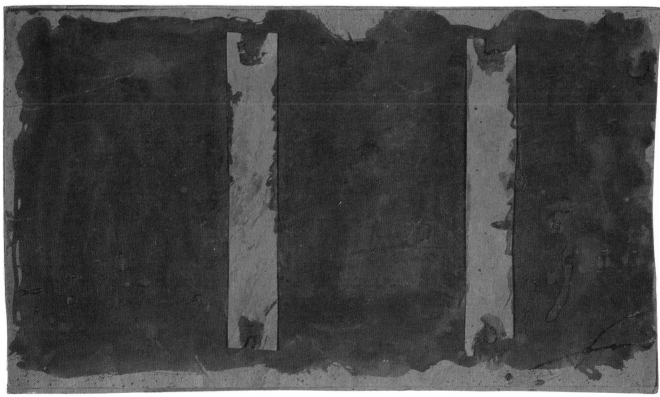

53 Untitled (sketch for Harvard mural), 1961
Tempera on colored construction paper
6¾ x 8 in.
(H17.2B)

54 Untitled (sketch for Harvard mural), 1961
Tempera and collage on colored construction paper
7 x 12⅛ in.
(H18.1F)

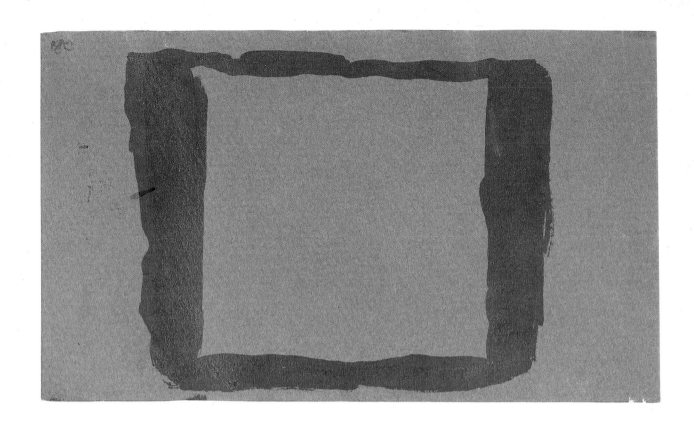

49 Untitled (model for Tate Gallery installation), 1969
Tempera on colored construction paper
3⅞ x 6⅝ in. (reproduced actual size)
(H14.7)

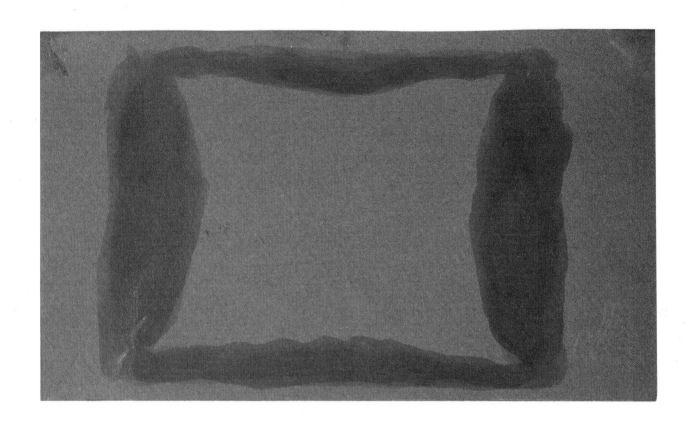

50 Untitled (model for Tate Gallery installation), 1969
Tempera on colored construction paper
3⅞ x 6⅝ in. (reproduced actual size)
(H14.8)

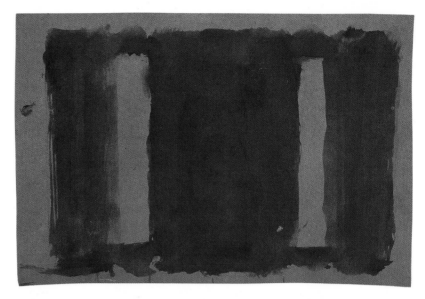

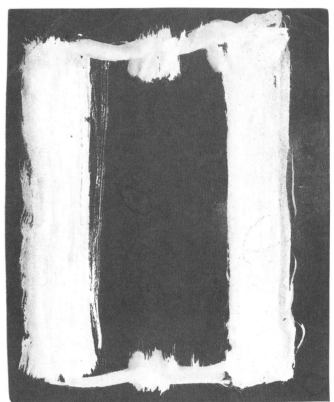

51 Untitled (sketch for Harvard mural), 1961
Tempera on colored construction paper
4^7/$_8$ x 7^1/$_4$ in.
(H15.2)

52 Untitled (sketch for Harvard mural), 1961
Tempera on colored construction paper
7^1/$_8$ x 6^1/$_8$ in.
(H17.1)

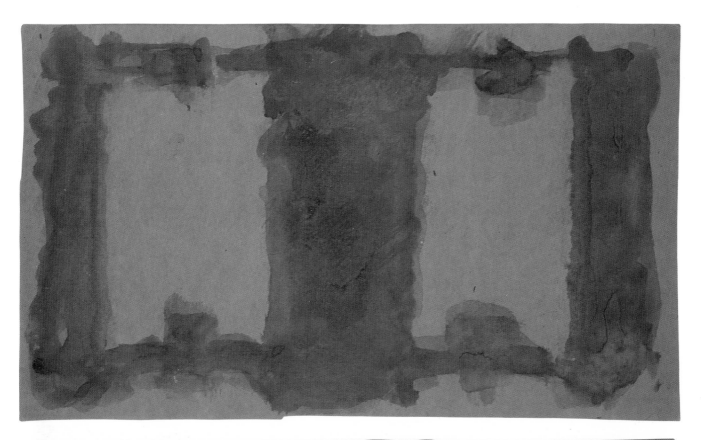

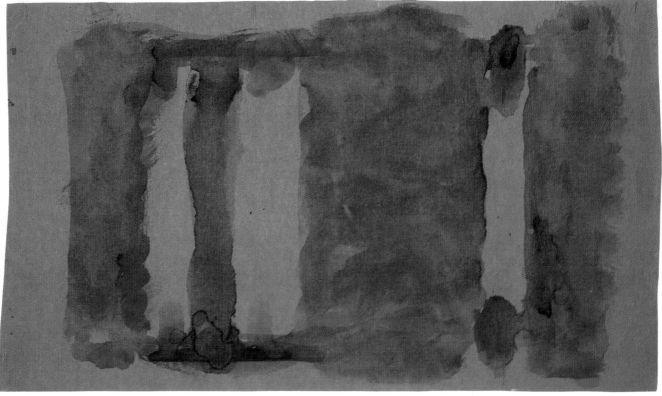

55 Untitled (sketch for Harvard mural), 1961
Tempera on colored construction paper
7 x 12¼ in.
(H18.2B)

56 Untitled (sketch for Harvard mural), 1961
Tempera on colored construction paper
7⅛ x 12¼ in.
(H18.3B)

57 Untitled (sketch for Harvard mural), 1961
Pen and ink on paper
11 x 8½ in.
(H23.6)

58 Untitled (sketch for Harvard mural), 1961
Pen and ink on paper
8½ x 11 in.
(H23.1)

59 Untitled, 1961
Pen and ink on paper
11 x 8½ in.
(H23.2)

60 Untitled, 1961
Pen and ink on paper
11 x 8½ in.
(H23.3)

61 Untitled, 1961
Pen and ink on paper
11 x 8½ in.
(H23.5)

62 Untitled, 1961
Pen and ink on paper
11 x 8½ in.
(H23.8)

63 Untitled (sketch for Chapel triptych), 1964/65
Pencil on colored construction paper
6¹¹/₁₆ x 9¾ in.
(H20.1F)

64 Untitled (sketch for Chapel triptych), 1964/65
Pencil on colored construction paper
6½ x 10⅜ in.
(H20.2)

65 Untitled (sketch for Chapel triptych), 1964/65
Pencil on colored construction paper
6⁹/₁₆ x 10⁵/₁₆ in.
(H20.3)

66 Untitled (sketch for Chapel triptych), 1964/65
Pencil on colored construction paper
9 x 12 in.
(H21.1)

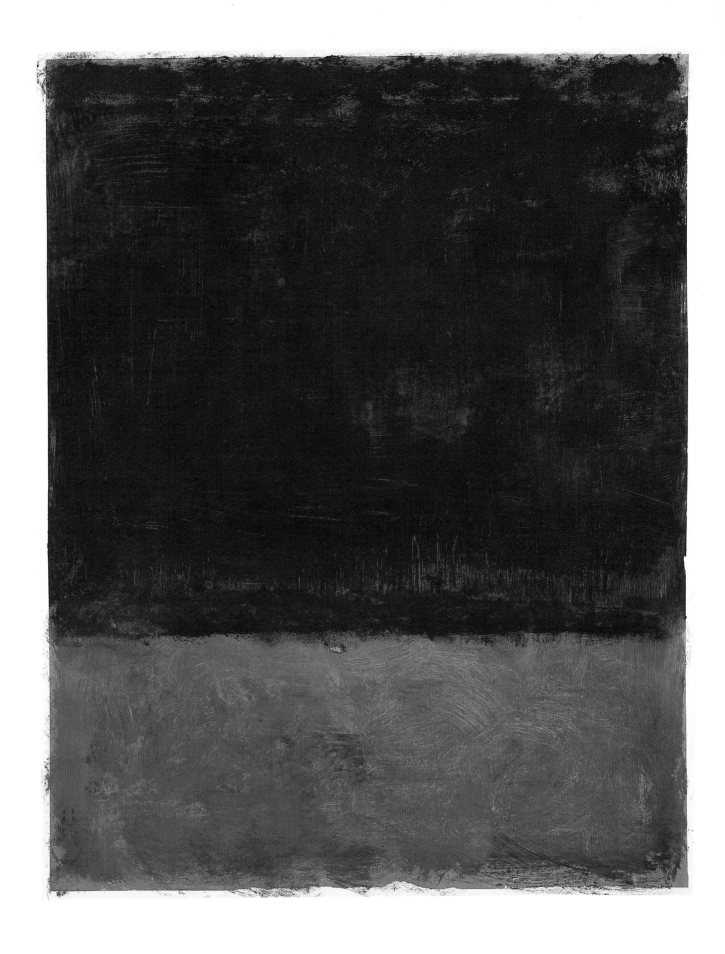

67 Untitled, 1969
Acrylic on paper
60³/₈ x 48⁵/₁₆ in.
(2076.69)

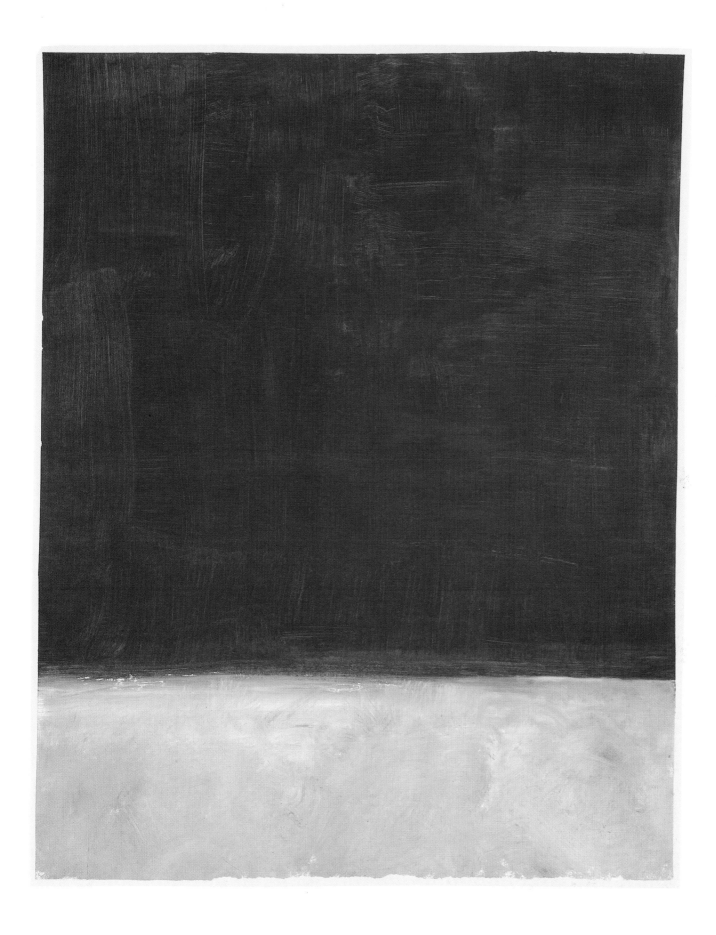

68 Untitled, 1969
Acrylic on paper
60¼ x 48¼ in.
(2085.69)

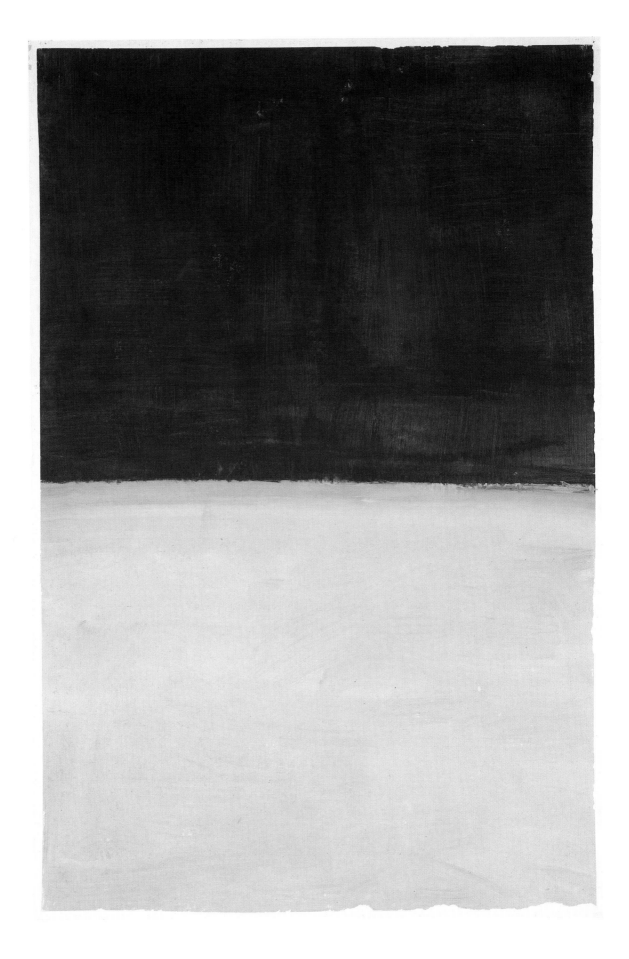

69 Untitled, 1969
Acrylic on paper
72³/₁₆ x 48⁷/₁₆ in.
(2098.69)

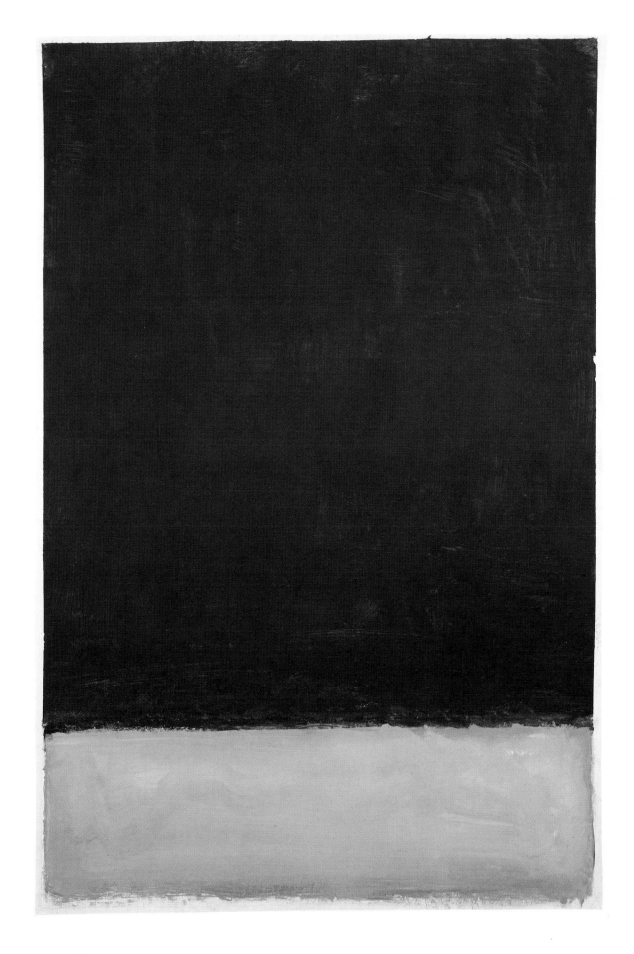

70 Untitled, 1969
Acrylic on paper
72$\frac{1}{16}$ x 48$\frac{5}{16}$ in.
(2088.69)

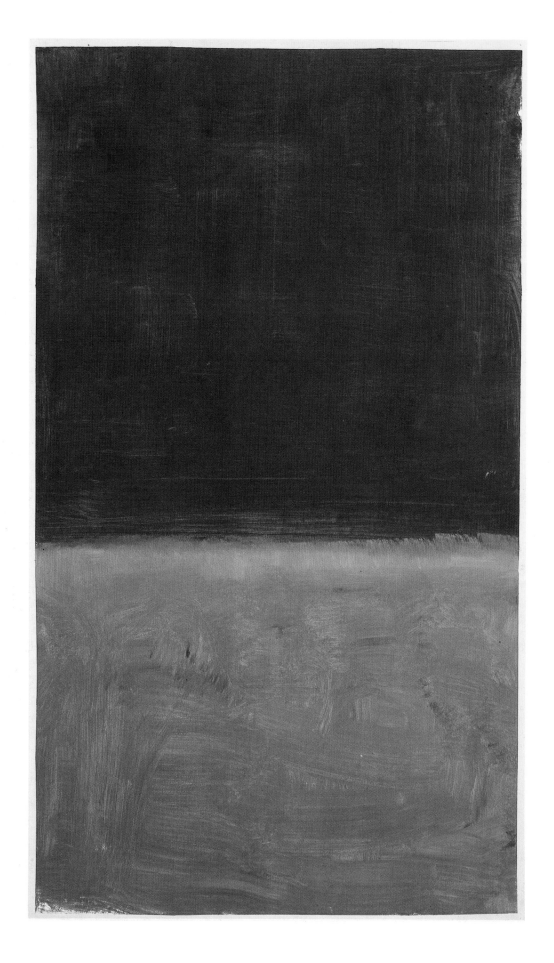

71 Untitled, 1969
Acrylic on paper
72$^{3}/_{16}$ x 42$^{7}/_{16}$ in.
(2091.69)

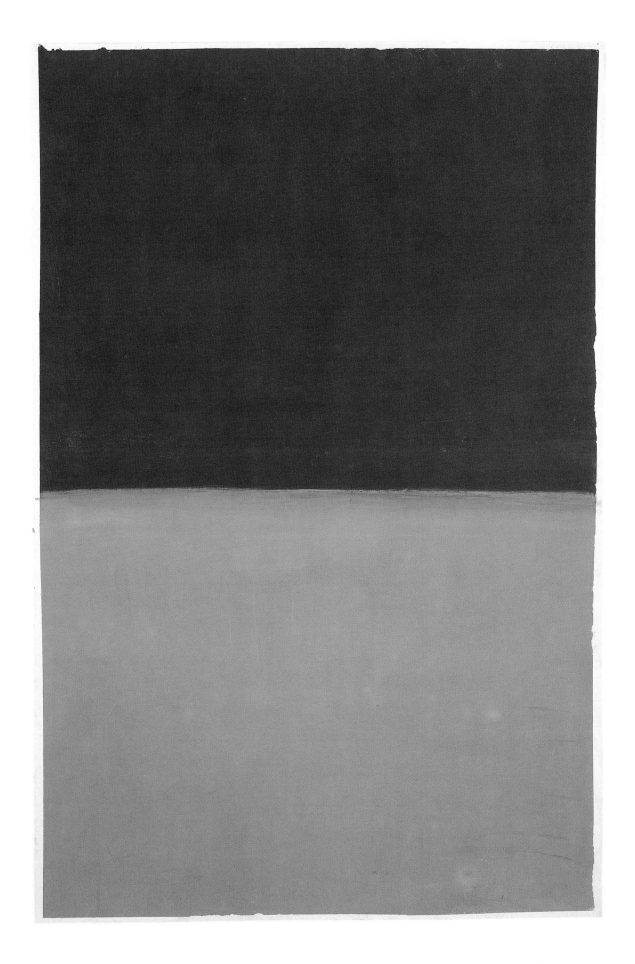

72 Untitled, 1969
Acrylic on paper
72$\frac{3}{16}$ x 48$\frac{7}{16}$ in.
(2096.69)

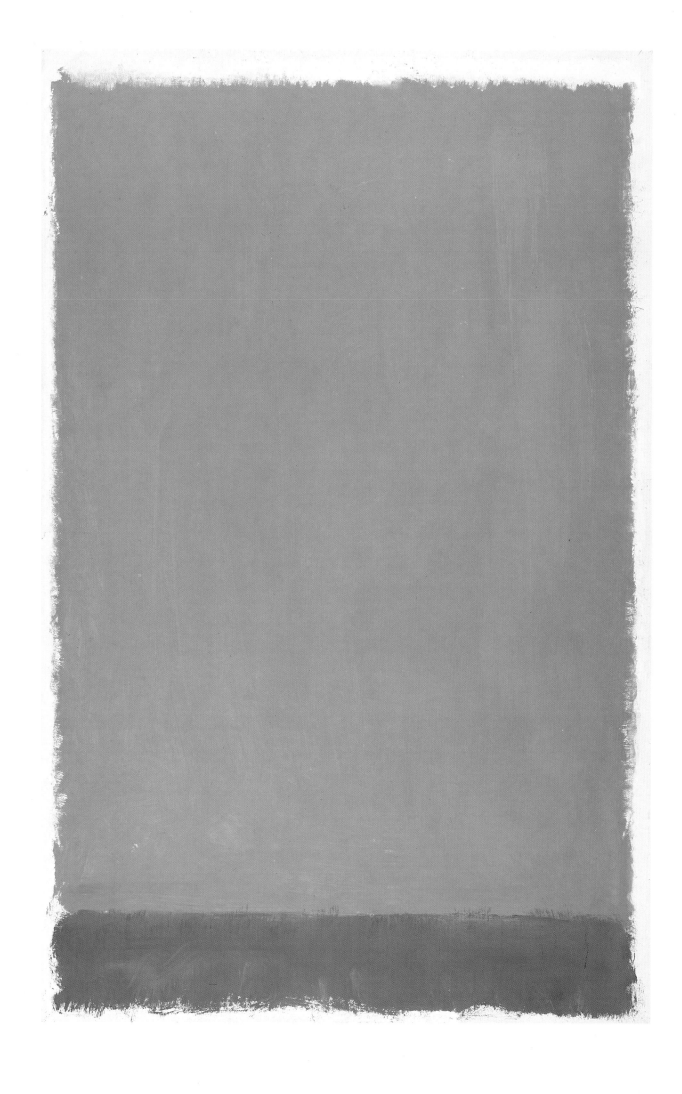

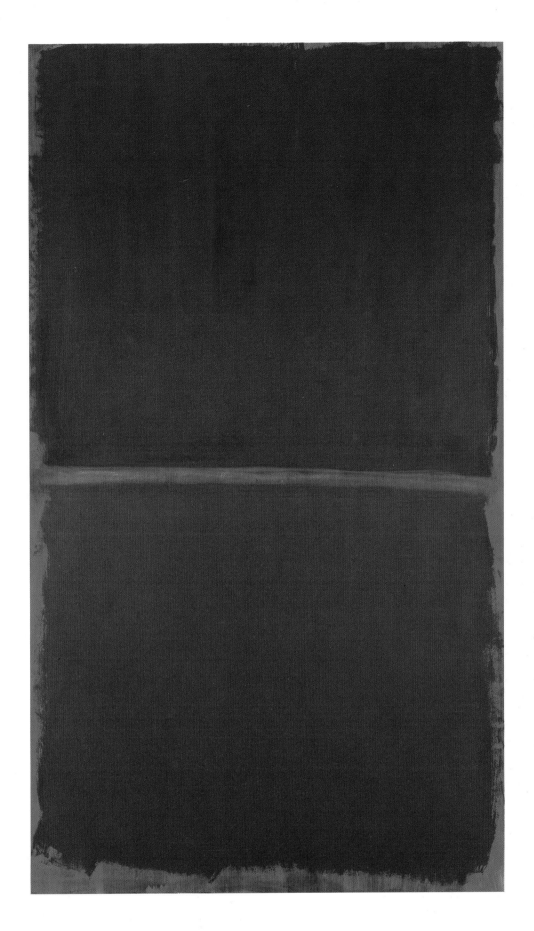

73 Untitled, 1969
Acrylic on paper
72 x 46 in. image
74⁵/₁₆ x 48⁵/₁₆ in. sheet
(1 ARC. 69)

74 Untitled, 1969
Acrylic, ink on paper
70⁹/₁₆ x 41¹/₁₆ in. image
72¹/₁₆ x 42¹/₈ in. sheet
(2035.69)
Lent by Kate and Christopher Rothko

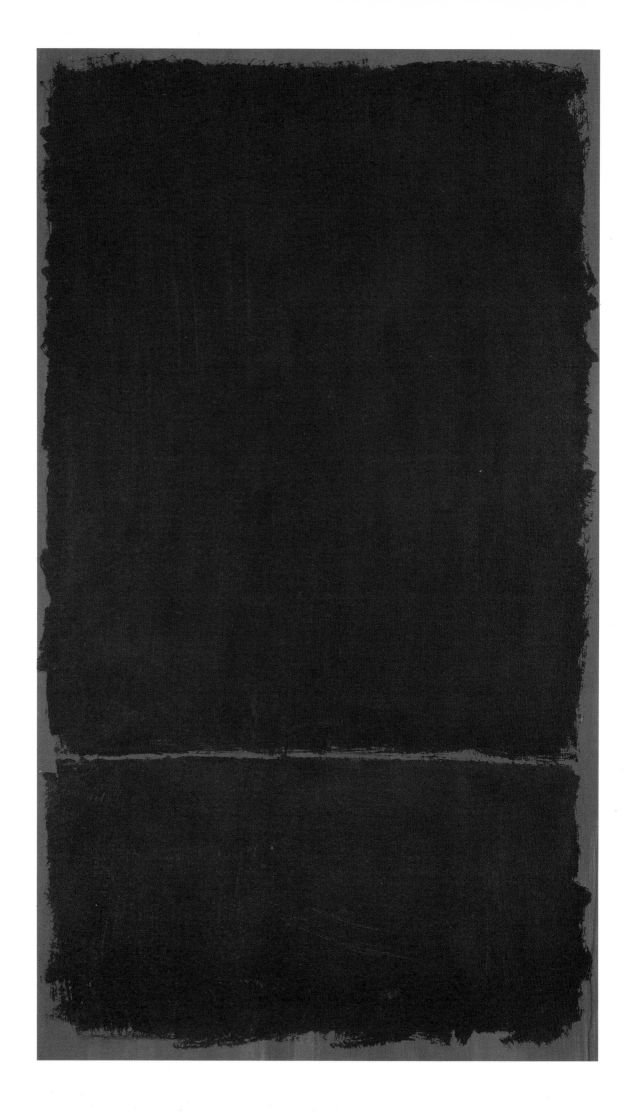

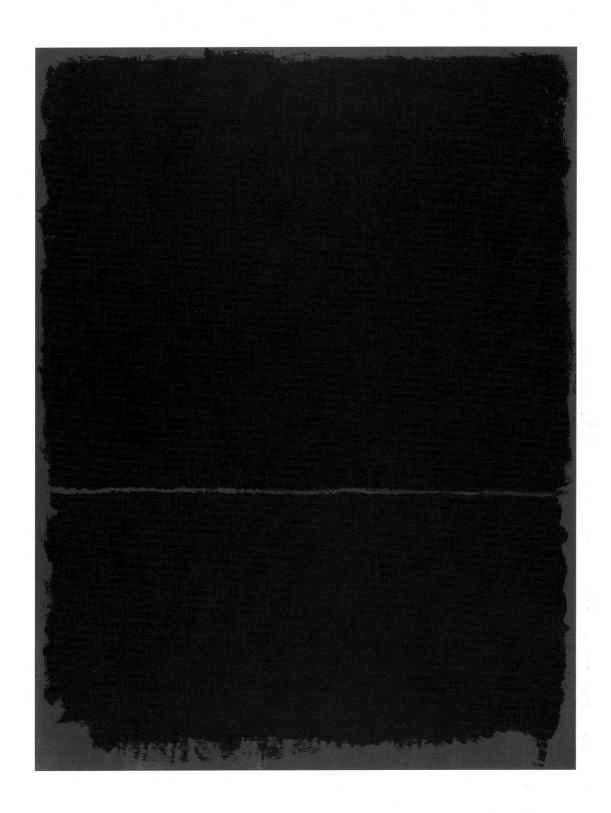

75 Untitled, 1969
Acrylic, ink on paper
71¼ x 41¼ in. image
72¼ x 42³/₁₆ in. sheet
(2036.69)
Lent by Kate and Christopher Rothko

76 Untitled, 1969
Acrylic, ink on paper
52¹³/₁₆ x 41⅛ in. image
54 x 42⅜ in. sheet
(2034.69)

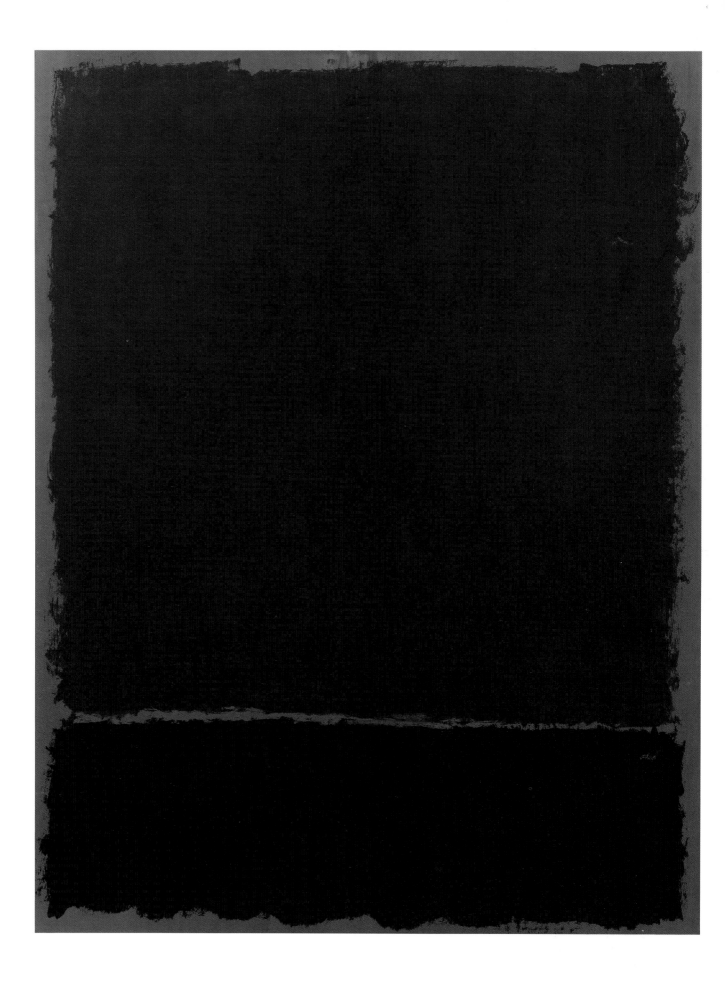

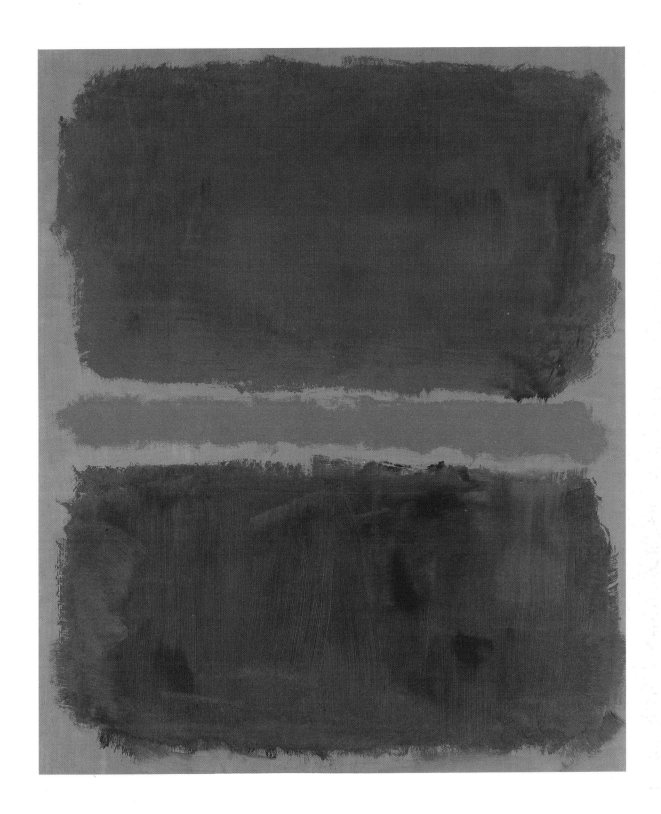

77 Untitled, 1969
Acrylic, ink on paper
52½ x 40¾ in. image
53¹¹⁄₁₆ x 42½ in. sheet
(2039.69)

78 Untitled, 1969
Acrylic, ink on paper
48¾ x 40¾ in. image
50¼ x 42¼ in. sheet
(2046.69)

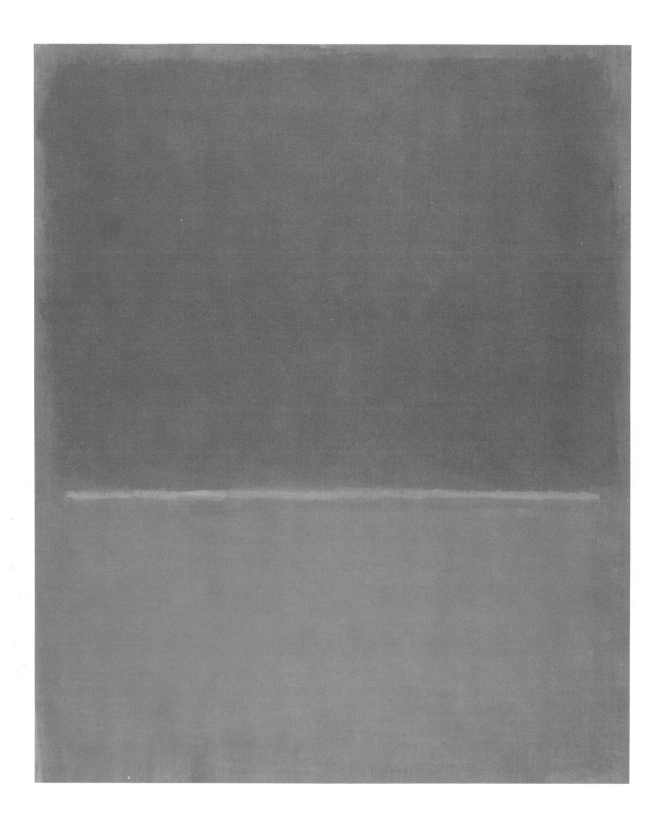

79 Untitled, 1969
Acrylic on paper
48¾ x 41¹/₁₆ in. image
50¹/₁₆ x 42¼ in. sheet
(2037.69)

80 Untitled, 1969
Acrylic, ink on paper
52⅝ x 41³/₁₆ in. image
54 x 42⅜ in. sheet
(2040.69)

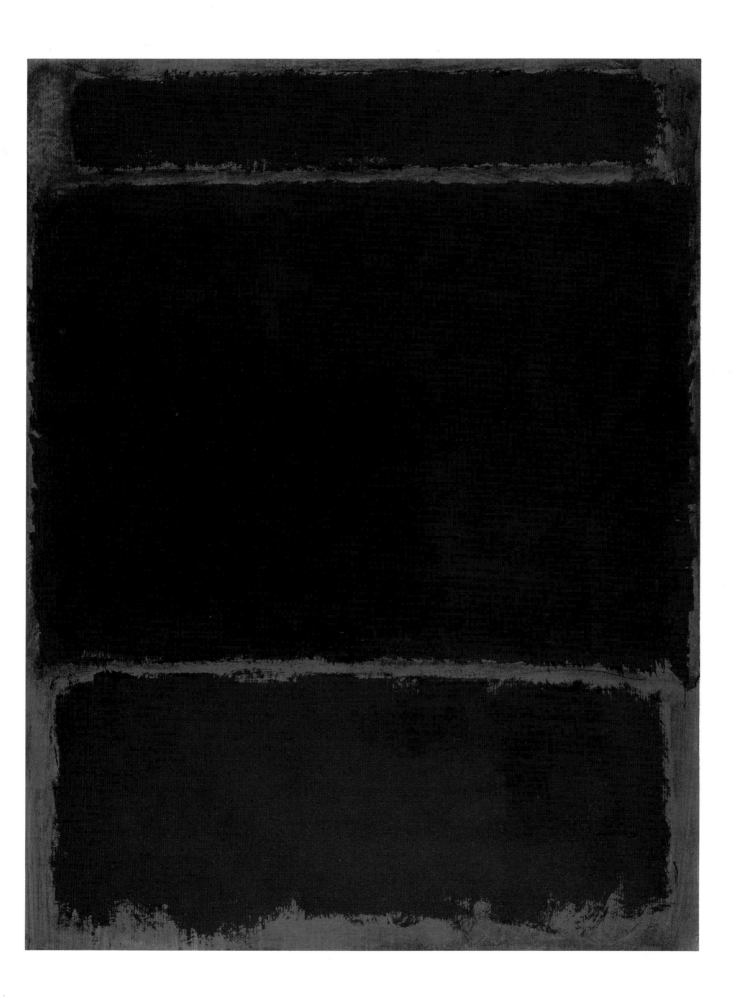

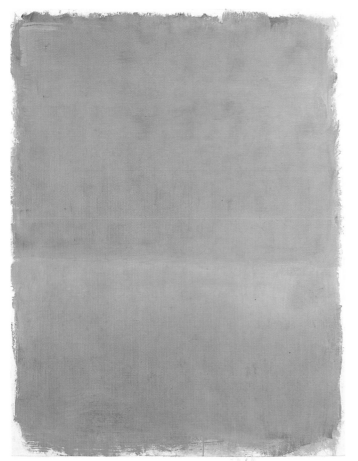

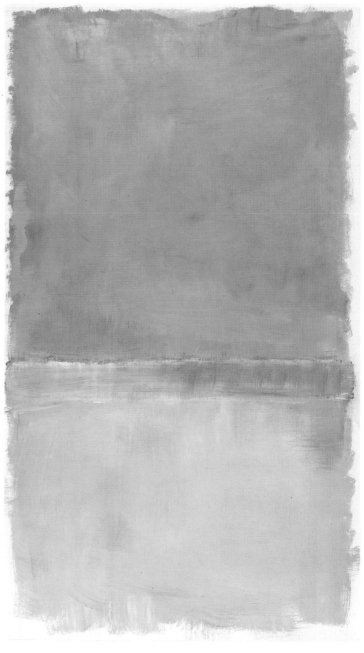

81 Untitled, 1969
Acrylic on paper
52⅝ x 40⅞ in. image
54 x 42⅜ in. sheet
(2025.69)

82 Untitled, 1969
Acrylic on paper
71⅜ x 41³/₁₆ in. image
72¾ x 42½ in. sheet
(2031.69)

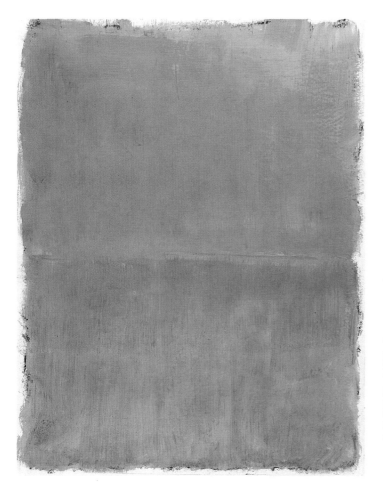

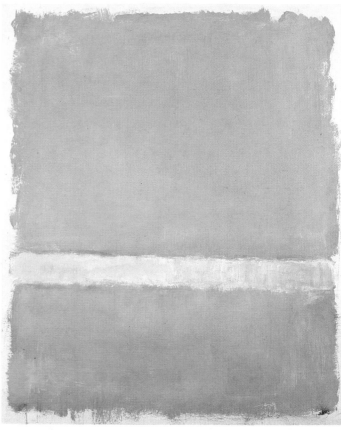

83 Untitled, 1969
Acrylic on paper
52⅝ x 41 in. image
54 x 42⁷/₁₆ in. sheet
(2050.69)

84 Untitled, 1969
Acrylic on paper
48¾ x 41¼ in. image
50¹/₁₆ x 42⁷/₁₆ in. sheet
(2027.69)

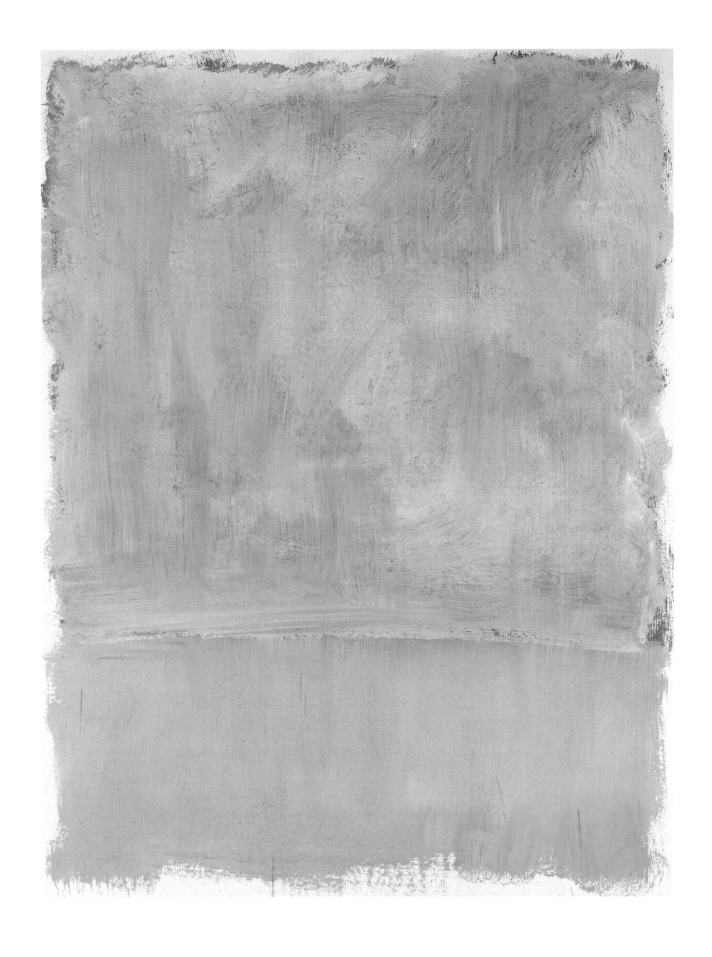

85 Untitled, 1969
Acrylic on paper
52^{15}/$_{16}$ x 41 in. image
54^{3}/$_{8}$ x 42^{7}/$_{16}$ in. sheet
(2049.69)

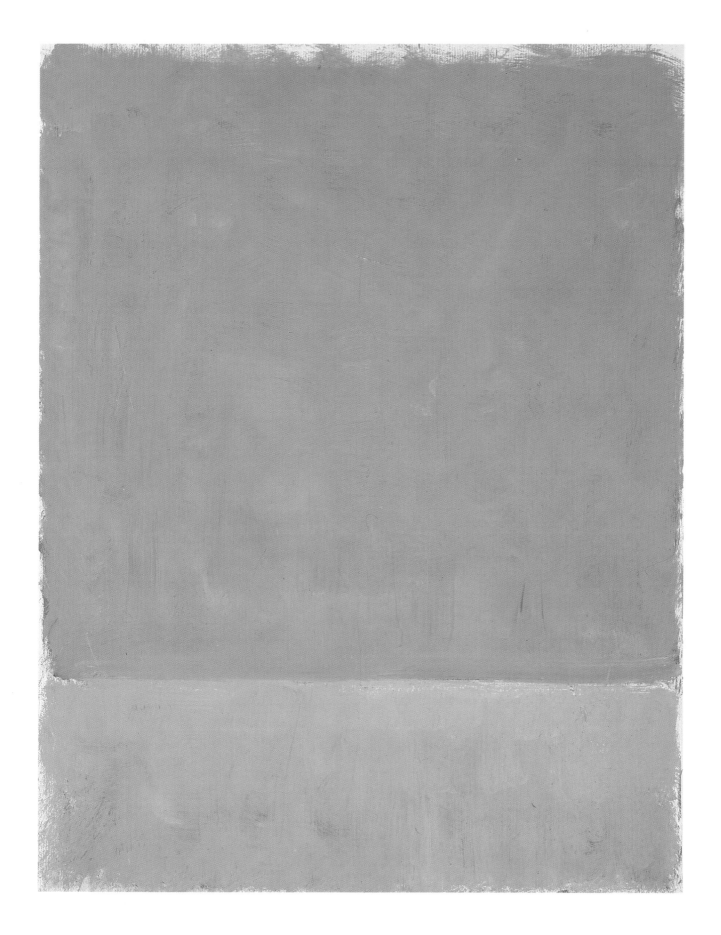

86 Untitled, 1969
Acrylic on paper
52$\frac{9}{16}$ x 41 in. image
53$\frac{7}{8}$ x 42$\frac{3}{8}$ in. sheet
(2066.69)
Lent by Kate and Christopher Rothko

CHECKLIST OF THE EXHIBITION

It would appear that Rothko usually titled his works only when he exhibited them. After 1947 he rarely titled them, although on occasion he would provide some works with a number. For exhibitions, galleries have created titles based on colors. The works listed below as Untitled have no titles inscribed on their backs.

In the dimensions, height precedes width. The legends in parentheses that appear at the end of each entry are inventory numbers. Those composed of 4 digits, a decimal point, and 2 to 4 additional digits—e.g., 1063.25/27—are numbers Rothko himself assigned to these works in 1968 and 1969; those composed of combinations of letters and numbers are arbitrary designations assigned by the Estate to works Rothko did not inventory.

Unless otherwise indicated, all works are from the Mark Rothko Foundation.

1 Untitled, late 1920s
Watercolor, ink, pencil on paper
$20\frac{1}{8}$ x $14\frac{3}{16}$ in. image
$22\frac{5}{16}$ x $15\frac{1}{8}$ in. sheet
(1063.25/27)

2 Untitled, late 1920s
Watercolor, ink on paper
$14\frac{1}{2}$ x 21 in. image
$15\frac{1}{2}$ x $22\frac{11}{16}$ in. sheet
(1083.25/27)

3 Untitled, c. 1930
Tempera on paper
$7\frac{3}{4}$ x $9\frac{13}{16}$ in. image
8 x 10 in. sheet
(N 30)

4 Untitled, 1930s
Tempera on colored construction paper
$11\frac{3}{8}$ x $7\frac{3}{4}$ in. image
12 x 8 in. sheet
(O 58)

5 Untitled, 1930s
Watercolor on paper
9 x $7\frac{1}{2}$ in.
(O 55)

6 Untitled (study for *Antigone*), early 1940s
Watercolor on paper
$5\frac{5}{8}$ x $6\frac{9}{16}$ in. image
$6\frac{1}{2}$ x 7 in. sheet
(N 5)

7 Untitled, early 1940s
Watercolor, pencil on paper
$4\frac{1}{2}$ x $6\frac{9}{16}$ in. image
$5\frac{1}{16}$ x $6\frac{15}{16}$ in. sheet
(O 19F)

8 Untitled, early 1940s
Pen and ink, pencil on paper
6 x 9 in.
(H6.4)

9 Untitled, 1944-45
Ink and pencil on paper
$22\frac{5}{8}$ x $15\frac{1}{2}$ in.
(1025.41)

10 Untitled, 1944-45
Ink on paper
$14\frac{1}{2}$ x $20\frac{1}{4}$ in. image
15 x $21\frac{1}{16}$ in. sheet
(1038.41F)

11 Untitled, 1944-45
Ink on paper
$14\frac{3}{4}$ x $22\frac{1}{8}$ in. image
$15\frac{9}{16}$ x $22\frac{5}{8}$ in. sheet
(1039.41)

12 Untitled, 1944-45
Watercolor, tempera, ink, pencil on paper
$21\frac{13}{16}$ x $27\frac{1}{8}$ in.
(1128.40)

13 Untitled, 1944-45
Watercolor, ink, tempera on paper
$21\frac{15}{16}$ x $30\frac{1}{16}$ in. image
$22\frac{9}{16}$ x $30\frac{15}{16}$ in. sheet
(1099.44)

14 Untitled, 1945-46
Watercolor, ink on paper
$26\frac{13}{16}$ x $19\frac{7}{8}$ in. image
$27\frac{1}{2}$ x $20\frac{1}{2}$ in. sheet
(1130.40)

15 Untitled, 1945-46
Watercolor, ink, tempera, pencil on paper
$20\frac{13}{16}$ x $14\frac{11}{16}$ in. image
$21\frac{1}{4}$ x $15\frac{1}{4}$ in. sheet
(1137.40)

16 Untitled, 1945-46
Watercolor, pencil, ink on paper
21¾ x 14⁹⁄₁₆ in. image
22½ x 15⁷⁄₁₆ in. sheet
(1036.41F)

17 Untitled, 1945-46
Watercolor, ink on paper
22⅛ x 30¹³⁄₁₆ in. image
22¾ x 31⁵⁄₁₆ in. sheet
(1134.40)

18 Untitled, 1945-46
Watercolor, ink on paper
39⅞ x 26⅜ in. image
40¹¹⁄₁₆ x 27¹⁄₁₆ in. sheet
(1007.45)

19 Untitled, 1945-46
Watercolor, ink on paper
40 x 26½ in. image
40⅝ x 27¹⁄₁₆ in. sheet
(1011.45)

20 Untitled, 1949
Watercolor, tempera on paper
39⁵⁄₁₆ x 26⁵⁄₁₆ in. image
40⅛ x 27 in. sheet
(1241.49)

21 Untitled, 1949
Watercolor, tempera on paper
39⅞ x 25⅞ in. image
40¹⁄₁₆ x 26⅝ in. sheet
(1243.49)

22 Untitled, 1949
Watercolor, tempera on paper
40³⁄₁₆ x 26¹⁄₁₆ in. image
41¹⁄₁₆ x 27¼ in. sheet
(1242.49)

23 Untitled, 1949
Watercolor, tempera on paper
39¾ x 26⁵⁄₁₆ in. image
42⅜ x 28⅜ in. sheet
(1238.49)
Lent by Kate and Christopher Rothko

24 Untitled, early 1950s
Watercolor, tempera on paper
39⅜ x 26½ in. image
40⅞ x 27³⁄₁₆ in. sheet
(1240.52)
Lent by Kate and Christopher Rothko

25 Untitled, early 1950s
Watercolor, tempera on paper
39⁹⁄₁₆ x 25¹³⁄₁₆ in. image
40½ x 27⅛ in. sheet
(1245.52)
Lent by Kate and Christopher Rothko

26 Untitled, 1959
Oil on paper mounted on Masonite
23⅞ x 18⅞ x ⅞ in.
Collection Mr. and Mrs. David A. Wingate, New York

27 Untitled, c. 1959
Oil on paper mounted on linen
30½ x 21¹⁵⁄₁₆ x ¹³⁄₁₆ in.
Collection Mr. and Mrs. David A. Wingate, New York

28 Untitled, 1967
Acrylic on paper mounted on Masonite
23¹⁵⁄₁₆ x 18¹³⁄₁₆ x 1⁷⁄₁₆ in.
(1255.67)

29 Untitled, 1967
Acrylic on paper mounted on Masonite
23⅞ x 18⅞ x 1⁷⁄₁₆ in.
(1268.67)

30 Untitled, 1967
Acrylic on paper mounted on Masonite
25⁹⁄₁₆ x 19¹¹⁄₁₆ x 1⁷⁄₁₆ in.
(1267.67)

31 Untitled, 1968
Acrylic on paper mounted on Masonite
32⅞ x 25⅜ x 1⁷⁄₁₆ in.
(1163.68)

32 Untitled, 1968
Acrylic on paper mounted on Masonite
39⅝ x 26⅛ x 1⁷⁄₁₆ in.
(1183.68)

33 Untitled, 1968
Acrylic on paper mounted on Masonite
34⅜ x 27¼ x 1⁷⁄₁₆ in.
(1185.68)

34 Untitled, 1968
Acrylic on paper mounted on Masonite
39⅛ x 25⅝ x 1⁷⁄₁₆ in.
(1173.68)

35 Untitled, 1968
Acrylic on paper mounted on Masonite
40¹¹⁄₁₆ x 26⅜ x 1⁷⁄₁₆ in.
(1184.68)

36 Untitled, 1968
Acrylic on paper mounted on Masonite
39¹¹⁄₁₆ x 25¾ x 1⁷⁄₁₆ in.
(1236.68)

37 Untitled, 1968
Acrylic on paper mounted on Masonite
39½ x 26³⁄₁₆ x 1⁷⁄₁₆ in.
(1162.68)

38 Untitled, 1968
Acrylic on paper mounted on Masonite
18¹⁄₁₆ x 11⅞ x 1⁷⁄₁₆ in.
(1289.68)

39 Untitled, 1968
Acrylic on paper mounted on Masonite
24¹/₁₆ x 18¼ x 1⁷/₁₆ in.
(1294.68)

40 Untitled, 1968
Acrylic on paper mounted on Masonite
18¹/₁₆ x 12¾ x 1⁷/₁₆ in.
(1288.68)

41 Untitled, 1968
Acrylic on paper mounted on Masonite
24⅛ x 18⅛ x 1⁷/₁₆ in.
(1286.68)

42 Untitled, 1968
Acrylic on paper mounted on Masonite
24¹/₁₆ x 18¹/₁₆ x 1⁷/₁₆ in.
(1295.68)

43 Untitled (sketch for Seagram murals), 1958-59
Crayon on colored construction paper
3¹¹/₁₆ x 18 in.
(H24.1)

44 *Mural Sketch 2* (sketch for Seagram murals), 1958-59
Tempera on paper
4½ x 16⅞ in.
(H25.2)

45 Untitled (model for Tate Gallery installation), 1969
Tempera on colored construction paper
3⅜ x 3 in.
(H14.1)

46 Untitled (model for Tate Gallery installation), 1969
Tempera on colored construction paper
4 x 3⅜ in.
(H14.2)

47 Untitled (model for Tate Gallery installation), 1969
Tempera on colored construction paper
2½ x 6⅜ in.
(H14.6)

48 Untitled (model for Tate Gallery installation), 1969
Tempera on colored construction paper
2½ x 6⅜ in.
(H14.5)

49 Untitled (model for Tate Gallery installation), 1969
Tempera on colored construction paper
3⅞ x 6⅝ in.
(H14.7)

50 Untitled (model for Tate Gallery installation), 1969
Tempera on colored construction paper
3⅞ x 6⅝ in.
(H14.8)

51 Untitled (sketch for Harvard mural), 1961
Tempera on colored construction paper
4⅞ x 7¼ in.
(H15.2)

52 Untitled (sketch for Harvard mural), 1961
Tempera on colored construction paper
7⅛ x 6⅛ in.
(H17.1)

53 Untitled (sketch for Harvard mural), 1961
Tempera on colored construction paper
6¾ x 8 in.
(H17.2B)

54 Untitled (sketch for Harvard mural), 1961
Tempera and collage on colored construction paper
7 x 12⅛ in.
(H18.1F)

55 Untitled (sketch for Harvard mural), 1961
Tempera on colored construction paper
7 x 12¼ in.
(H18.2B)

56 Untitled (sketch for Harvard mural), 1961
Tempera on colored construction paper
7⅛ x 12¼ in.
(H18.3B)

57 Untitled (sketch for Harvard mural), 1961
Pen and ink on paper
11 x 8½ in.
(H23.6)

58 Untitled (sketch for Harvard mural), 1961
Pen and ink on paper
8½ x 11 in.
(H23.1)

59 Untitled, 1961
Pen and ink on paper
11 x 8½ in.
(H23.2)

60 Untitled, 1961
Pen and ink on paper
11 x 8½ in.
(H23.3)

61 Untitled, 1961
Pen and ink on paper
11 x 8½ in.
(H23.5)

62 Untitled, 1961
Pen and ink on paper
11 x 8½ in.
(H23.8)

63 Untitled (sketch for Chapel triptych), 1964/65
Pencil on colored construction paper
6¹¹/₁₆ x 9¾ in.
(H20.1F)

64 Untitled (sketch for Chapel triptych), 1964/65
Pencil on colored construction paper
6½ x 10⅜ in.
(H20.2)

65 Untitled (sketch for Chapel triptych), 1964/65
Pencil on colored construction paper
6⁹⁄₁₆ x 10⁵⁄₁₆ in.
(H20.3)

66 Untitled (sketch for Chapel triptych), 1964/65
Pencil on colored construction paper
9 x 12 in.
(H21.1)

67 Untitled, 1969
Acrylic on paper
60³⁄₈ x 48⁵⁄₁₆ in.
(2076.69)

68 Untitled, 1969
Acrylic on paper
60¼ x 48¼ in.
(2085.69)

69 Untitled, 1969
Acrylic on paper
72³⁄₁₆ x 48⁷⁄₁₆ in.
(2098.69)

70 Untitled, 1969
Acrylic on paper
72¹⁄₁₆ x 48⁵⁄₁₆ in.
(2088.69)

71 Untitled, 1969
Acrylic on paper
72³⁄₁₆ x 42⁷⁄₁₆ in.
(2091.69)

72 Untitled, 1969
Acrylic on paper
72³⁄₁₆ x 48⁷⁄₁₆ in.
(2096.69)

73 Untitled, 1969
Acrylic on paper
72 x 46 in. image
74⁵⁄₁₆ x 48⁵⁄₁₆ in. sheet
(1 ARC. 69)

74 Untitled, 1969
Acrylic and ink on paper
70⁹⁄₁₆ x 41¹⁄₁₆ in. image
72¹⁄₁₆ x 42¹⁄₈ in. sheet
(2035.69)
Lent by Kate and Christopher Rothko

75 Untitled, 1969
Acrylic, ink on paper
71¼ x 41¼ in. image
72¼ x 42³⁄₁₆ in. sheet
(2036.69)
Lent by Kate and Christopher Rothko

76 Untitled, 1969
Acrylic, ink on paper
52¹³⁄₁₆ x 41¹⁄₈ in. image
54 x 42³⁄₈ in. sheet
(2034.69)

77 Untitled, 1969
Acrylic, ink on paper
52½ x 40¾ in. image
53¹¹⁄₁₆ x 42½ in. sheet
(2039.69)

78 Untitled, 1969
Acrylic, ink on paper
48¾ x 40¾ in. image
50¼ x 42¼ in. sheet
(2046.69)

79 Untitled, 1969
Acrylic on paper
48¾ x 41¹⁄₁₆ in. image
50¹⁄₁₆ x 42¼ in. sheet
(2037.69)

80 Untitled, 1969
Acrylic, ink on paper
52⁵⁄₈ x 41³⁄₁₆ in. image
54 x 42³⁄₈ in. sheet
(2040.69)

81 Untitled, 1969
Acrylic on paper
52⁵⁄₈ x 40⁷⁄₈ in. image
54 x 42³⁄₈ in. sheet
(2025.69)

82 Untitled, 1969
Acrylic on paper
71³⁄₈ x 41³⁄₁₆ in. image
72¾ x 42½ in. sheet
(2031.69)

83 Untitled, 1969
Acrylic on paper
52⁵⁄₈ x 41 in. image
54 x 42⁷⁄₁₆ in. sheet
(2050.69)

84 Untitled, 1969
Acrylic on paper
48¾ x 41¼ in. image
50¹⁄₁₆ x 42⁷⁄₁₆ in. sheet
(2027.69)

85 Untitled, 1969
Acrylic on paper
52¹⁵⁄₁₆ x 41 in. image
54³⁄₈ x 42⁷⁄₁₆ in. sheet
(2049.69)

86 Untitled, 1969
Acrylic on paper
52⁹⁄₁₆ x 41 in. image
53⁷⁄₈ x 42³⁄₈ in. sheet
(2066.69)
Lent by Kate and Christopher Rothko

CHRONOLOGY

This chronology lists the major facts of Rothko's life, important one-man exhibitions as well as group and one-man exhibitions that included works on paper, and selected reviews. For a comprehensive chronology of Rothko's life and career, see Diane Waldman, *Mark Rothko 1903-1970: A Retrospective.* New York: Harry N. Abrams in collaboration with the Solomon R. Guggenheim Museum, 1978.

1903 *September 25.* Marcus Rothkowitz born in Dvinsk, Russia, to Jacob and Anna Goldin Rothkowitz, youngest of four children.

1910 Father emigrates to the United States, settles in Portland, Oregon.

1911 Two brothers join father in Portland.

1913 Emigrates to America with mother and sister, is reunited with father and brothers in Portland.

1914 Father dies.

1921-23 Attends Yale University, New Haven.

1923 Moves to New York.

1924 *January-February.* Takes anatomy course with George Bridgman at Art Students League.

1925 *October-December.* Studies painting with Max Weber at Art Students League. Paints on canvas and paper in an expressionistic style influenced by Weber. Depends heavily on preparatory sketches.

1926 *March-May.* Resumes studies with Max Weber at Art Students League.

1929 Begins teaching art to children at the Center Academy, Brooklyn Jewish Center. (Keeps position until 1952.)

1932 *November.* Marries Edith Sachar.

1933 *Summer.* Portland, Oregon, Museum of Art. First one-man exhibition. Drawings and watercolors exhibited with work of students at the Center Academy, Brooklyn. □ Catherine Jones. "Noted One-Man Show Artist One-Time Portland Resident." *Sunday Oregonian* (Portland), July 30, 1933.

November 21-December 9. New York, Contemporary Arts Gallery. *An Exhibition of Paintings by Marcus Rothkowitz.* First one-man exhibition in New York. Includes watercolors and black tempera paintings on paper. □ Jane Schwartz. "Around the Galleries." *Art News,* 32, no. 9 (December 2, 1933), p. 16.

1935 Co-founds an independent art group, The Ten. Members include Ben Zion, Ilya Bolotowsky, Adolph Gottlieb, Louis Harris, Jack Kufeld, Louis Schanker, Joseph Solman, and Nahum Tschachbasov. Exhibits with The Ten in New York and Paris until the breakup of the group in 1940.

1936 Employed by easel division of the Works Projects Administration in New York. (Employment lasts until 1939.)

1938 Becomes a United States citizen.

1940 Begins to use the name Mark Rothko.

1941 Uses mythic imagery and subjects in canvases and works on paper.

March 9-23. New York, Riverside Museum. *The First Annual Exhibition of the Federation of Modern Painters and Sculptors.* Checklist. 1 work on paper.

1943 *June.* With Adolph Gottlieb writes letter to Edward Alden Jewell, art critic of the *New York Times.*

1944 Works in an abstract Surrealist style. Produces numerous works on paper using watercolor, gouache, ink, and tempera.

1945 *March.* Divorced from Edith Sachar. Marries Mary Alice (Mell) Beistel.

January 9-February 4. New York, Art of This Century. *Mark Rothko Paintings.* Catalogue with unsigned text. Includes gouaches. □ Edward Alden Jewell. "Art: Diverse Shows." *New York Times,* January 14, 1945.

May 14-July 7. New York, 67 Gallery. *A Problem for Critics.* Group show. 1 watercolor. □ Robert M. Coates. "The Art Galleries: Water Colors and Oils." *New Yorker,*

21, no. 15 (May 26, 1945), p. 68; Maude Riley. "Insufficient Evidence." *Art Digest,* 19, no. 17 (June 1, 1945), p. 12. Watercolor ill.; Edward Alden Jewell. "Toward Abstract or Away? A Problem for Critics." *New York Times,* July 1, 1945.

1946 *Spring.* Paints last Surrealist works on paper.

February 5-March 13. New York, Whitney Museum of American Art. *Annual Exhibition of Contemporary American Sculpture, Watercolors and Drawings.* Catalogue. 1 watercolor. □ Thomas B. Hess. "The Whitney Draws Slowly to the Left." *Art News,* 45, no. 1 (March 1946), pp. 29, 62. Watercolor ill.

April 22-May 4. New York, Mortimer Brandt Gallery. *Mark Rothko: Watercolors.* Checklist. 18 watercolors. □ Edward Alden Jewell. "Art: Hither and Yon." *New York Times,* April 28, 1946; "Reviews and Previews." *Art News,* 45, no. 2 (April 1946), p. 55; Ben Wolf. "Mark Rothko Watercolors." *Art Digest,* 20, no. 15 (May 1, 1946), p. 19.

August 13-September 8. San Francisco Museum of Art. *Oils and Watercolors by Mark Rothko.* Travels in part to the Santa Barbara Museum of Art (September).

1947 Canvases and works on paper become more abstract. Paints few works on paper during this transitional period.

Summer. Teaches painting and lectures on contemporary art at California School of Fine Arts, San Francisco.

March 3-22. New York, Betty Parsons Gallery. First of five annual one-man exhibitions.

April 16-June 8. New York, The Brooklyn Museum. *International Watercolor Exhibition, 14th Biennial.* Catalogue. 1 work on paper. □ Thomas B. Hess. "One World in Watercolor." *Art News,* 46, no. 3 (May 1947), pp. 25, 54-55.

1948 *January 31-March 21.* New York, Whitney Museum of American Art. *Annual Exhibition of Contemporary American Sculpture, Watercolors and Drawings.* Catalogue. 1 work on paper.

May 29-September 30. Venice, *La XXIV Biennale di Venezia: La Collezione Peggy Guggenheim.* Catalogue with texts by Bruno Alfieri and Peggy Guggenheim. 1 watercolor.

1949 *Summer.* Teaches painting and lectures on contemporary art at California School of Fine Arts.

April 2-May 8. New York, Whitney Museum of American Art. *Annual Exhibition of Contemporary American Sculpture, Watercolors and Drawings.* Catalogue.

1950 Begins painting in his classic style. Stacks two or three rectangles of glowing color on large stained canvases. Works on paper reflect the new development and

some are probably studies for the large canvases. Mother dies.

Spring. Sails to Europe, visits England, France, and Italy.

December. Daughter, Kathy Lynn (Kate), born.

February 21-March 5. New York, Lotos Club. *Exhibition of Watercolors and Sculpture by the Members of the Federation of Modern Painters and Sculptors.*

1951 *February.* Appointed Assistant Professor, Department of Design, Brooklyn College. (Holds position until June 1954.)

1954 *October 18-December 31.* The Art Institute of Chicago. *Recent Paintings by Mark Rothko.* Travels in part to Museum of Art, Rhode Island School of Design, Providence, as *Paintings by Mark Rothko,* January 19-February 13, 1955.

1955 *April 11-May 14.* New York, Sidney Janis Gallery. First of two one-man exhibitions.

1957 *February-March.* Visiting artist at Tulane University, New Orleans. Begins to limit palette to dark colors.

1958 *June.* Receives commission to paint murals for the Seagram Building, New York. Sails to Europe with family, visits England, France, Italy, Belgium, and The Netherlands.

October. Delivers lecture at Pratt Institute, Brooklyn.

1959 After painting three sets of murals for the Seagram Building commission reconsiders the environment intended for their display and withdraws from the commission.

1961 Receives commission to paint murals for the penthouse of Harvard University's Holyoke Center. Donates commissioned murals to Harvard.

October. Travels to London.

January 18-March 12. New York, The Museum of Modern Art. *Mark Rothko.* Catalogue by Peter Selz. Major retrospective. Travels October 1961-January 1963 to: Whitechapel Art Gallery, London; Stedelijk Museum, Amsterdam; Palais des Beaux-Arts, Brussels; Kunsthalle Basel; Galleria Nazionale d'Arte Moderna, Rome; Musée d'Art Moderne de la Ville, Paris. Catalogues published in language of each country. 4 watercolors. □ Robert M. Coates. "The Art Galleries: In the Museums," *New Yorker,* 36, no. 50 (January 28, 1961), pp. 78-81; Robert Goldwater. "Reflections on the Rothko Exhibition." *Arts, 35,* no. 6 (March 1961) pp. 42-45.

November 15-December 10. New York, Whitney Museum of American Art. *American Art of Our Century: 30th Anniversary Exhibition.* Catalogue by John I. H. Baur and Lloyd Goodrich. 2 works on paper.

1963 *January.* Sends 6 mural panels to Harvard University. Visits Harvard to select 5 panels for permanent installation in the penthouse of the Holyoke Center.

August. Son, Christopher Hall, born.

April 9-June 2. New York, The Solomon R. Guggenheim Museum. *Five Mural Panels Executed for Harvard University by Mark Rothko.*

1964 *Spring.* Receives commission from John and Dominique de Menil to paint murals for a chapel in Houston.

February-March. London, Marlborough New London Gallery. *Mark Rothko.* Catalogue. 5 works on paper.

December 31-March 7, 1965. London, The Tate Gallery. *The Peggy Guggenheim Collection.* Catalogue by Peggy Guggenheim. 1 watercolor.

1965 Begins discussing with Norman Reid, director of the Tate Gallery, London, gift to the gallery of the paintings included in the 1961 retrospective exhibition at the Whitechapel Art Gallery, London.

1966 *June.* Sails to Europe with family, visits Italy, France, The Netherlands, Belgium, London.

1967 *Summer.* Teaches at the University of California, Berkeley.

February-April. Houston, University of St. Thomas Art Department. *Six Painters.* Catalogue with texts by Morton Feldman, Thomas B. Hess, and Dominique de Menil. 1 work on paper.

September 30-November 5. Washington, D.C., Washington Gallery of Modern Art. *Art for Embassies Selected from the Woodward Foundation Collection.* Catalogue. 2 works on paper.

1968 *Spring.* Suffers an aneurysm of the aorta, hospitalized for three weeks.

Summer. Presents *Sketch for Mural No. 6* to the Tate Gallery, London, through the American Federation of Arts. Rents house in Provincetown, Massachusetts. Paints primarily on paper from now on. Begins painting brown and gray works and large colorful works on paper.

Fall. Catalogues collection. (Continues inventory through 1969.)

January 30-February 25. Irvine, University of California, Art Gallery. *Twentieth-Century Works on Paper.* Travels to Memorial Union Art Gallery, University of California, Davis, March 26-April 20. Catalogue by James Monte. 1 work on paper.

March 13-April 24. New York, Finch College Museum of Art. *Betty Parsons' Private Collection.* Catalogue by E. C. Goossen. 2 works on paper.

1969 *January.* Separates from wife, leaves home and moves into studio. Begins painting black and gray canvases.

June. Receives Honorary Degree, Doctor of Fine Arts, from Yale University. The Mark Rothko Foundation incorporated.

September. Selects group of Seagram murals with Norman Reid for donation to the Tate Gallery, London. Paints miniature copies of murals which he arranges on a model of the room at the Gallery.

January 16-March 23. New York, The Solomon R. Guggenheim Museum. *Works of Art from the Peggy Guggenheim Foundation.* Catalogue. 1 watercolor.

October 16-February 1, 1970. New York, The Metropolitan Museum of Art. *New York Painting and Sculpture: 1940-1970.* Catalogue with texts reprinted or revised from earlier publications by Michael Fried, Henry Geldzahler, Clement Greenberg, Harold Rosenberg, Robert Rosenblum, William Rubin. 3 watercolors.

1970 *February 25.* Commits suicide in studio.

June 21-October 15. Venice, Museo d'Arte Moderna Ca' Pesaro. *Mark Rothko.* Organized under the auspices of the Biennale Internazionale de Venezia, with the collaboration of Marlborough Gallery, New York/London/Rome. Catalogue with text by Guido Perocco. Travels to Marlborough Gallery, New York, November 13-December 5. □ Thomas B. Hess. "Rothko: A Venetian Souvenir." *Art News,* 69, no. 7 (November 1970), pp. 40-41, 72-74; Kenneth Baker. "New York." *Artforum,* 9, no. 5 (January 1971), pp. 74-75.

1971 *February 27.* Dedication of the Rothko Chapel, Houston.

February. Rome, Marlborough Galleria d'Arte. *Mark Rothko.* Catalogue with excerpts from previously published texts by Marie-Claude Dane, Sam Hunter, Georgine Oeri, Peter Selz, Guido Perocco, Michel Ragon, and Rothko. Travels March to Galleria Lorenzelli, Bergamo. 17 works on paper.

March 21-May 9. Zurich, Kunsthaus. *Mark Rothko.* Catalogue with texts by Felix Andreas Baumann, Werner Haftmann, Donald McKinney, and Rothko. Travels May 1971-May 1972 to: Staatliche Museen Preussischer Kulturbesitz, Neue Nationalgalerie, Berlin; Städtische Kunsthalle, Düsseldorf; Museum Boymans-van Beuningen, Rotterdam; in part to: Hayward Gallery, London; Musée National d'Art Moderne, Paris. Separate catalogue in the language of each country. 8 works on paper.

1974 *January 30-March 10.* Newport Beach, Calif., Newport Harbor Art Museum. *10 Major Works: Mark Rothko.* Catalogue by James B. Byrnes and Morton H. Levine. 3 works on paper.

1975 *October 16-January 25, 1976.* New York, The Jewish Museum. *Jewish Experience in the Art of the Twentieth Century.* Catalogue. 2 works on paper.

1976 *January 23-March 28.* New York, The Solomon R. Guggenheim Museum. *Twentieth-Century American Drawing: Three Avant-Garde Generations.* Catalogue by Diane Waldman. Travels May 26-August 29 to: Staatliche Kunsthalle, Baden-Baden; Kunsthalle Bremen. Separate catalogue in German with additional text by Hans Albert Peters. 6 works on paper. □ Roberta Smith. "Drawing Now (And Then)." *Artforum,* 14, no. 8 (April 1976), pp. 52-59.

1977 *March 5-April 24.* New Brunswick, N.J., Rutgers University Art Gallery. *Surrealism and American Art: 1931-1947.* Catalogue with texts by Jack J. Spector and Jeffrey Wechsler. 2 works on paper.

1978 *March 30-May 14.* Ithaca, N.Y., Herbert F. Johnson Museum of Art. *Abstract Expressionism: The Formative Years.* Organized by Herbert F. Johnson Museum of Art and Whitney Museum of American Art, New York. Catalogue by Robert Carleton Hobbs and Gail Levin. Travels June 17-December 3 to: The Seibu Museum of Art, Tokyo; Whitney Museum of American Art, New York. 5 works on paper.

June 1-January 14, 1979. Washington, D.C., National Gallery of Art. *American Art at Mid-Century: The Subjects of the Artist.* Catalogue with text by E. A. Carmean, Jr., Eliza E. Rathbone, and Thomas B. Hess. 8 works on paper. □ Paul Richard. "Seven Abstract American Heroes." *Washington Post,* June 11, 1978.

October 27-January 14, 1979. New York, The Solomon R. Guggenheim Museum. *Mark Rothko 1903-1970: A Retrospective.* Catalogue with texts by Diane Waldman and Bernard Malamud. Travels in part February-September to: The Museum of Fine Arts, Houston; Walker Art Center, Minneapolis; Los Angeles County Museum of Art. 42 works on paper. □ Robert Hughes. "The Rabbi and the Moving Blur." *Time,* 112, no. 19 (November 6, 1978), pp. 108-9. Work on paper ill.; Hilton Kramer. "Rothko—Art as Religious Faith." *New York Times,* November 12, 1978; Stephen Polcari. "Mark Rothko." *Arts Magazine,* 53, no. 5 (January 1979), p. 3. Work on paper ill.

October 28-November 25. New York, Pace Gallery. *Rothko: The 1958-1959 Murals.* Catalogue with text by Arnold Glimcher and interview with Dan Rice.

1980 *May 31-July 13.* Berlin, Schloss Charlottenburg, Grosse Orangerie. *Zeichen des Glaubens—Geist der Avantgarde.* Catalogue with text by Wieland Schmied, Otto Mauer, Gunter Rombold, Hans Maier, Rainer Volp, Hans Kung, Friedhelm W. Fischer, Paul Tillich, Horst Schwebel, Hans H. Hofstatter, Hans Haufe, Jonos Frecot, Wolf-Dieter Dube, Eberhard Roters, Herman Kern, Robert Rosenblum, Hannah Weitemeier-Steckel, Antje von Graevenitz, Anton Henze, Harold Szeemann. 2 works on paper.

1981 *April 24-May 30.* New York, Pace Gallery. *Mark Rothko, The Surrealist Years.* Catalogue with text by Robert Rosenblum. 21 works on paper. □ Grace Glueck. "Art: Rothko as Surrealist in His Pre-Abstract Years." *New York Times,* May 1, 1981; Roberta Smith. "Mark Rothko's Surrealistic Billows." *Village Voice* (New York), May 6-12, 1981.

1983 *February 6-March 27.* Minneapolis, Walker Art Center. *Mark Rothko: Seven Paintings from the 1960's.* Organized by the Mark Rothko Foundation. Catalogue with text by Bonnie Clearwater. 3 works on paper.

April 1-April 30. New York, Pace Gallery. *Mark Rothko, Paintings 1948-69.* Catalogue with text by Irving Sandler. 5 works on paper.

BIBLIOGRAPHY

For an extensive bibliography on the work of Mark Rothko, see Diane Waldman, *Mark Rothko 1903-1970: A Retrospective,* New York: Harry N. Abrams in collaboration with the Solomon R. Guggenheim Museum, 1978.

Writings, statements, letters, interviews by the artist, arranged chronologically

On art education. Late 1930s. Notebook. The George C. Carson Family Collection, on extended loan to the Mark Rothko Foundation, New York.

On art education. Late 1930s. Notes in a sketchbook. The Mark Rothko Foundation, New York.

Drafts of a letter to Edward Alden Jewell. June 1943. The George C. Carson Family Collection, on extended loan to the Mark Rothko Foundation, New York.

Letter. Marcus Rothko and Adolph Gottlieb, with unacknowledged collaboration of Barnett Newman. In Edward Alden Jewell, "The Realm of Art: A New Platform and Other Matters: "'Globalism' Pops into View," *New York Times,* June 13, 1943. Copy of letter on deposit in Rothko file, The Museum of Modern Art, New York.

"The Portrait and the Modern Artist." Radio broadcast with Adolph Gottlieb. *Art in New York,* WNYC, October 13, 1943. Transcript published in *Adolph Gottlieb: A Retrospective.* New York: The Arts Publisher in association with the Adolph and Esther Gottlieb Foundation, 1981, pp. 170-71.

"Personal Statement." In Washington, D.C., David Porter Gallery. *A Painting Prophecy—1950.* February 1945.

"Clyfford Still." In New York, Art of This Century. *Clyfford Still.* January 9-February 4, 1946.

Letter. To Laurine Collins, The Brooklyn Museum, New York. May 21, 1947. On file at the Brooklyn Museum.

Statement. In "The Ideas of Art: The Attitudes of 10 Artists on Their Art and Contemporaneousness." *The Tiger's Eye,* 1, no. 2 (December 1947), p. 44.

"The Romantics Were Prompted." *Possibilities 1* (Winter 1947/48), p. 84.

Statement. *The Tiger's Eye,* 1, no. 9 (October 1949), p. 114.

Statement. In "A Symposium on How to Combine Architecture, Painting and Sculpture," *Interiors,* 110, no. 10 (May 1951), p. 104.

Editor's Letters. *Art News,* 56, no. 8 (December 1957), p. 6.

Quotation. In Selden Rodman. *Conversations with Artists.* New York: Devin-Adair, 1957, pp. 93, 94.

Lecture. Pratt Institute, Brooklyn, N.Y., October 27, 1958. Quoted in Dore Ashton, "Art: Lecture by Rothko," *New York Times,* October 31, 1958; in New York, Pace Gallery. *Mark Rothko: Paintings 1948-1969.* April 1-30, 1983, pp. 11-12.

Letter. To Ronald Alley, The Tate Gallery, London. February 1, 1960. On deposit in Rothko file, The Tate Gallery, London.

Interview with Katharine Kuh. c. 1961. On deposit in Katharine Kuh papers, Archives of American Art, Smithsonian Institution, Washington, D.C.

Instructions to the Whitechapel Art Gallery, London, regarding the installation of his retrospective exhibition, 1961. On deposit in Rothko file, Whitechapel Art Gallery, London.

Letter. To Bryan Robertson, Director, Whitechapel Art Gallery, London. September 12, 1961. On deposit in Rothko file, Whitechapel Art Gallery, London.

Letter. To John and Dominique de Menil. January 1, 1966. On deposit in Rothko file, Menil Foundation, Houston. Facsimile excerpt in *The Rothko Chapel,* Houston, 1979, p. 4.

General references

Alley, Ronald. *Catalogue of The Tate Gallery's Collection of Modern Art: Other than Works by British Artists.* London: The Tate Gallery, 1981.

Ashton, Dore. *The New York School: A Cultural Reckoning.* New York: Viking Press, 1972.

—————. *American Art since 1945.* London: Oxford University Press, 1982.

Greenberg, Clement. *Art and Culture: Critical Essays.* Boston: Beacon Press, 1961.

Janis, Sidney. *Abstract and Surrealist Art in America*. New York: Reynal & Hitchcock, 1944.

O'Doherty, Brian. *American Masters: The Voice and the Myth*. New York: Random House, 1973.

Rosenblum, Robert. *Modern Painting and the Northern Romantic Tradition: Friedrich to Rothko*. New York: Harper & Row, 1975.

Sandler, Irving. "Modernist American Drawing." In *Great Drawings of All Time: The Twentieth Century,* vol. 2. New York: Shorewood, 1981, n.p.

_____ . *The Triumph of American Painting: A History of Abstract Expressionism*. New York: Praeger, 1970.

Seitz, William C. "Abstract-Expressionist Painting in America: An Interpretation Based on the Work and Thought of Six Key Figures." Ph.D diss. Princeton University, 1955; Cambridge, Mass.: Harvard University Press, 1983.

Monographs

Ashton, Dore. *About Rothko*. New York: Oxford University Press, 1983.

Seldes, Lee. *The Legacy of Mark Rothko*. New York: Holt, Rinehart and Winston, 1979.

Waldman, Diane. *Mark Rothko 1903-1970: A Retrospective*. New York: Harry N. Abrams in collaboration with the Solomon R. Guggenheim Museum, 1978.

Articles

Ashton, Dore. "Mark Rothko." *Arts and Architecture,* 74, no. 8 (August 1957), pp. 8, 31.

_____ . "Art: Lecture by Rothko." *New York Times,* October 31, 1958.

Collier, Oscar. "Mark Rothko." *The New Iconograph,* no. 4 (Fall 1947), pp. 41-44.

de Kooning, Elaine. "Two Americans in Action: Franz Kline and Mark Rothko." *Art News Annual,* 27 (1958), pp. 87-97, 174-79.

Fischer, John. "Mark Rothko: Portrait of the Artist as an Angry Man." *Harper's,* 241, no. 1442 (July 1970), pp. 16-23.

Goldwater, Robert. "Rothko's Black Paintings." *Art in America,* 59, no. 2 (March-April 1971), pp. 58-63.

MacAgy, Douglas. "Mark Rothko." *Magazine of Art,* 42, no. 1 (January 1949), pp. 20-21.

Polcari, Stephen. "The Intellectual Roots of Abstract Expressionism: Mark Rothko." *Arts Magazine,* 54, no. 1 (September 1979), pp. 124-34.

Reid, Norman. "The Mark Rothko Gift: A Personal Account." In *The Tate Gallery 1968-70*. London: The Tate Gallery, 1970, pp. 26-29.

Spencer, Charles. "People." In *The Year's Art 1969-70: Europe and the U.S.A.* Edited by Michael Dempsey. London: Hutchinson & Co., 1971, pp. 32-37.

INDEX

Unless otherwise noted, all works by Rothko are on paper. *Italic* page numbers and Plate numbers (indicating the section of colorplates following page 62) refer to illustrations.